LANDSCAPE ILLUSION

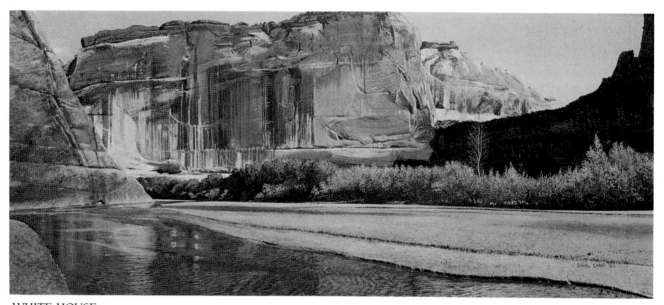

WHITE HOUSE
1982, acrylic on paper, 7″ × 16″ (18 × 41 cm),
private collection, courtesy of O.K. Harris Works of Art

LONG SHADOWS
1984, acrylic on board, 17½″ × 31″ (44 × 79 cm), private collection,
courtesy of O.K. Harris Works of Art, photo by D. James Dee

LANDSCAPE
ILLUSION

DANIEL CHARD

FOREWORD BY JOHN ARTHUR

WATSON-GUPTILL PUBLICATIONS / NEW YORK

To my mother and father

Copyright © 1987 by Daniel Chard

First published in 1987 by Watson-Guptill Publications, a division of BPI Communications, Inc., 1515 Broadway, New York, N.Y. 10036

Library of Congress Cataloging-in-Publication Data
Chard, Daniel, 1938–
 Landscape Illusion
 Includes index.
 1. Landscape painting—Technique. 2. Visual perception. I. Title.
ND1342.C46 1987 751.42′6 87-2091
ISBN 0-8230-2596-9
ISBN 0-8230-2594-2 (pbk.)

Paperback Edition
First Printing 1993

1 2 3 4 5 6 7 / 99 98 97 96 95 94 93

Printed in Japan

Daniel Chard, a native of South Jersey, currently lives in Elmer, New Jersey. He received his B.F.A. from the University of South Dakota and a doctorate in education from Teachers College, Columbia University. Since 1968 he has been teaching art at Rowan College of New Jersey. He shows his paintings at O.K. Harris Works of Art in New York, and his prints are represented by Orion Editions. More than two hundred of his paintings are in corporate and private collections.

ACKNOWLEDGMENTS

It was Mary Suffudy, senior editor at Watson-Guptill, who initiated this project. She supported and nourished my ideas over a period of almost four years. After we established the concept of the book, Mary recommended that Betty Vera help me develop the structure of the book and elaborate its contents. Betty gave unselfishly and helped me order and rethink the book from beginning to end. The final edit was performed by Sue Heinemann, and it was a remarkable performance. She consumed and fine-tuned the material, building evenness and proportion in the text. These three editors gave the book every opportunity to be as good as it could be. I will always be indebted for the opportunity they gave me to share my thoughts with others.

From the beginning, I was concerned with the look of the book. But, with Areta Buk, the book was in the hands of a talented graphic designer. She solved many important problems that made the book work more effectively.

THE FIELDS, EVER TURNING

Painting land is a Promethean act,
a sleight-of-hand trick pulled off
right under God's nose—apparently

with impunity. My trespassing
in His fields also mostly has gone
unnoticed. I have seen the grass

erase my print in no time flat,
each blade rising to its own occasion,
not mine. Yet my taste for space

has never dulled, even when strung
and hung in hygienic halls without
the benefit of weather. I think

it strange how these square fields
which shrink toward infinity find
their counterparts in my memory

where the past resides like faded
fragments in a Minoan fresco, speaking
a partial tale. Art, always someone's

private truth, is the final conceit,
an optical deceit, like horizons—
and all we know of permanence.

—*John V. Chard*

CONTENTS

TOWARD BENSON
1985, screen print, 5″ × 20″ (13 × 51 cm),
private collection, courtesy of Orion Editions

**HORSETHIEF
CANYON**
1982, acrylic on paper,
18″ × 10½″ (46 × 27 cm),
private collection,
courtesy of O.K. Harris
Works of Art,
photo by Benjamin Fisher

FOREWORD

BY JOHN ARTHUR

Most painters evolve toward their personal and authentic center in metamorphic stages, with many false starts and wrong turns on the precarious path toward mature, individual vision. Daniel Chard is one of those rare exceptions who made a quantum leap from minimal abstractions to crystalline landscape images (which were first attempted for the most personal reasons), with no intermediate steps.

These landscape paintings are highly deceptive in regard to their apparent objectivity, the minimal sign of the hand, and their small size. Each of these factors, and certainly the combined weight of all three, beg for comparison to photography, for indeed, they have the scale and look of photographs and are, in fact, derived from photographs.

The look and ambience of Chard's paintings seem closer to their nineteenth-century American precedents, such as the paintings of Frederick Church, Albert Bierstadt, and John Frederick Kensett, and the photographs of Eadweard Muybridge, Carleton Watkins, and Timothy O'Sullivan. In their work, as in Chard's, the romantic impulse and personal vision are easily overlooked due to the obvious exactitude in depicting the landscape.

But Chard is a contemporary painter, and his work must be considered in the present context.

The art of our most recent decades has been marked primarily by its pluralistic forms of expression and diverse aspects of figuration. To be a realist is an act of choice, and to paint from photographs is a choice of means.

Regarding the current use of photography in painting, it is essential that a distinction be made between the two major methods that have evolved over the past twenty years, for the more literal photographic replications of the photo-realist painters, such as Ralph Goings, Richard McLean, and Charles Bell, are distinctly different from the transliterations of photographic source material by Richard Estes, James Valerio, and the more recent work of Chuck Close.

While there are many adjustments and much fine-tuning, a photo-realist painting owes its fidelity to a photographic image, with all its inherent characteristics such as lens distortion, depth of field, and the peculiarities of emulsified color and light. In a photo-derived painting, which would include Chard's work, the photograph is a point of reference to which the finished painting will correspond in general, but will not duplicate.

As with Estes, Close, and Valerio, an examination of the photographic source material used by Chard will clarify the extent of editing and adjusting made in the process of its translation into a painted image. It is immediately obvious that Chard is a superb craftsman. His incisive draftsmanship, skillful manipulation of tone and color, and ability to suggest and abbreviate the tactile particulars of the landscape are fused with his formal capacity for reordering the spatial structure of the topography and suggesting a vast space within a very small parameter.

Whether it is the deeply familiar fields and backyards of his native New Jersey, the rolling hills of Vermont, where he has summered, or the vast, western regions he has visited, those formal and painterly skills are consistently evident in his diminutive panoramas. These factors, coupled with an aversion to sentimentality and pictorial clichés, separate his landscapes from that great multitude of predictable and spiritless works.

Daniel Chard is a popular painter with a large audience and market, for we all respond favorably to American scenery, but we are so struck by his facility that we are in danger of underestimating his formal and interpretive skills, which are considerable.

If there is an inherent flaw, it is not in Chard's vision, which is personal, poetic, and authentic, but in our failure to comprehend the subjective nature of his vision. Nonetheless, our enchantment with his paintings is sustained, and their quiet mysteries are not diminished.

INTRODUCTION

Some things about painting are more important to me than others. From the beginning I want to state my belief that, for the realist painter, it is composition that provides the greatest leverage for developing far-reaching visual statements. Composition is what separates the great paintings of the past from the academic ones.

For many people, composition is an intimidating and somewhat mysterious subject, but it needn't be. One aim of this book is to give both those who paint and those who simply enjoy looking at paintings a better idea of what constitutes good composition, how it can be brought about, and the overall impact it can have on painting.

My emphasis on composition derives from my own development, both as a painter and as a person who appreciates art. During the sixties, I spent a lot of time trying to discover the workings of the language of painting, especially with regard to composition. As I looked at art in museums, I gradually became aware of certain paintings, which were particularly intriguing and inspiring to me. They seemed to have an inexhaustible complexity, and they also tugged at me spiritually. A single work by Rogier van der Weyden, *Christ on the Cross with*

St. John and the Virgin, especially impressed me with its complexity. It indicated to me what painting could be—the kind of painting that would be worth doing, if I could.

Over the years I have found only a few artists in the entire history of art who have been able to develop this kind of complexity. Each period has produced many artists who could handle subject matter and painting techniques in a sophisticated way, but their work often falls short when it comes to compositional structure. Further, I have become convinced that it is the integration of *all* aspects of a painting idea, as articulated on a two-dimensional surface, that makes the most forceful paintings. To my mind, van der Weyden, Rembrandt, Raphael, and Degas are among those who have developed the most exciting works in this regard.

At different times in my painting career, different artists have been important to me. During the late sixties, Mondrian was of particular interest to me, as I felt he continued, in an abstract way, the formal tradition of the old masters. My own paintings at this time were abstract, involved with the organization of geometric patterns and sometimes having very tight compositions with subtle spatial dynamics. I was work-

ing with the shallow, predominantly two-dimensional picture space of modern art rather than with the illusion of deep space.

Although my interest in composition was strong, I had yet to discover a suitable outlet for this interest. At the time, in addition to painting, I survived in the academic world as a teacher, giving but also taking courses and writing papers for an advanced degree. I tried to take academia seriously, and I would have liked to do scholarly things. However, I did not yet understand where my greatest strengths lay, and I had not learned to believe in my intuition. (I had only a limited understanding of this side of myself—some experience with playing the piano by ear as an amateur musician, and the knowledge that, as a teacher, I think better on my feet in the classroom than when I try to sit down and plan my statements in a more deliberate way.) I was working with painting problems that focused on spontaneity, but somehow I wasn't investing myself heavily enough in my abstract paintings.

I spent some frustrating years in college administration, which led to a period of limited productivity. Finally I went through a mini-burnout and stopped painting al-

NO. 10
1974, acrylic on raw canvas, 54″ × 84″ (137 × 213 cm), private collection, courtesy of O.K. Harris Works of Art

This abstract painting represents my "optical" style, which used conflicting horizontal patterns, created by spraying acrylic on raw canvas. My other style at this time was a reductionist one, based on the tenets of Mondrian, involving symmetrical structures and simple geometric shapes.

together. After moving to the country for a much-needed change of scene, I decided to paint something that interested me rather than trying to do an "important" painting. That is how I became involved in the landscape, which led to a breakthrough in my work.

It was approximately three years from the time I actually stopped painting until I began painting realistically. I didn't do it because of a desire to paint this way. I simply became interested in the scenery around me. The local community had put together a book about the history of the area, with accompanying photographs. An area a few hundred yards from my house had been a factory complex less than one hundred years ago, and I was fascinated by the photographs of this now unimportant part of the town. I decided to do a painting of a photograph of the area as it was then and became intrigued by the way the painting was going. Without finishing this painting, I decided to take some photographs of the town for a possible painting. One photograph especially interested me, and I did a painting the same size. It was okay, but I wanted more space in the painting. At the same time, I wanted to continue to work small, to allow for detail. So I went to a

small panorama format of 3 × 13 inches (8 × 33 cm).

I continued to use these unusual dimensions, and within a short period of time, I had done quite a few of these miniature realist panoramas. Initially I was interested only in making pictures and in the clarity of the image. But as the landscape idea developed, so did my formalist approach, in which composition and the quality of order in the image became more important than the subject matter. Soon I was back to where I had left off with my abstractions—a preoccupation with structure and organization. This time, however, my knowledge of space was much further developed than before.

Eakins and Caravaggio became the artists who showed me the most about how to locate objects on the picture plane while building a strong three-dimensional illusion. Eakins's work in particular is unique in its ability to convey a sense of volume without detracting from the unity of the two-dimensional design. The elaborate relationship between two- and three-dimensional space provides uncommon latitude for developing ideas, since any variation in this structure provides an opportunity for visual tension, which evokes a response in the viewer.

Artists such as Eakins are the masters of understatement, which is at the heart of formalism, and they continue to be an inspiration to me.

It wasn't until I had experimented with realism just for the pleasure of it, and achieved success with my landscapes at the O.K. Harris gallery in New York, that I began to put a great deal of energy into my painting. I did more than two hundred realist landscapes in five years, and in the process, I began to find out about my creative skills and to develop a new technical ease I hadn't had before—and hadn't known was possible. The rigor and continuous practice that led to my new-found facility could be compared to doing scales on the piano—except that, for me, painting was much more natural.

I have so many ideas for paintings that my work is planned ahead for the next several years. I have not made a mark on paper for any of these paintings, but they exist in my mind, and I have patience and faith that I will paint my way there. I consider an idea for many months before I try it out. I may even think about it for a long time and then discard it without ever starting the painting, or even doing a drawing for it. I have to be convinced about a painting before I can go ahead

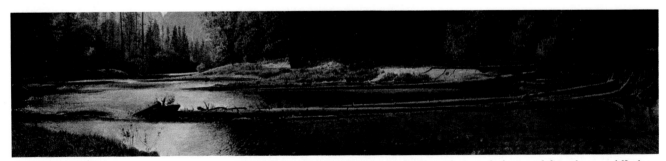

FALLEN TREES
1980, acrylic on paper, 3″ × 13″
(8 × 33 cm), private collection,
courtesy of O.K. Harris Works of Art

This kind of panoramic format places so much emphasis on the horizontal that it becomes difficult to perceive the picture frame as a rectangle. Using this format, I found it was possible to capture the expanse of the landscape, without necessarily requiring a large-size painting surface.

with it: it should have quality and originality, but it also should serve as a springboard for further painting ideas.

I haven't yet done the painting I want to do; and I don't expect I ever will, because the possibilities keep expanding. I have a general idea of where my work will go, and I am trying to establish on canvas something about my experience on this planet. My paintings are positive—sympathetic to the subject matter—and that will continue.

In providing this profile of myself as a painter, I am not writing solely about painting; I am also trying to indicate the personal journey that painting has allowed me to take. Had I been born a hundred years ago under different circumstances, I might be engaged in some other kind of activity: I might even be working in the fields instead of painting them. It is just that, given my particular talents and disposition, painting has provided the best laboratory for me to find out about myself and the world around me.

My discoveries in painting have also allowed me to put into perspective the more traditional kinds of knowledge—what some people call "facts." As a friend of mine says, reflecting on the limits of human reason, "Logic is okay for getting you to the store and back." Myself, I have less and less confidence in what there is to learn from the logical side of the brain; as an artist, I have invested heavily in my feelings and intuition.

While I don't want to overstate how much my life has changed because of my experiences as a painter, I will say that they have made it easier for me to become the person I think I am. There is change

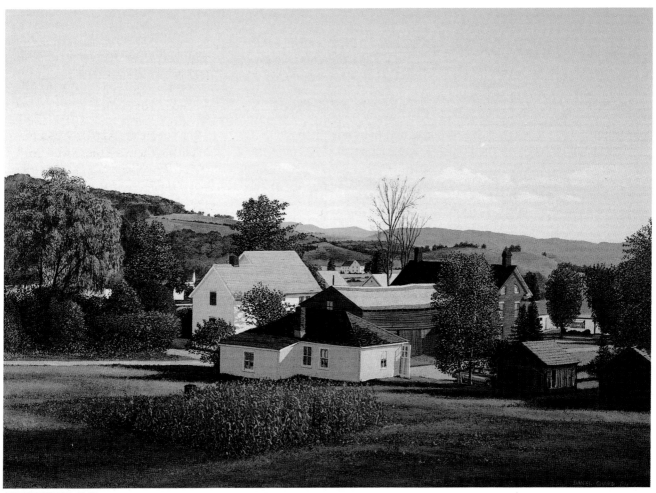

WEST RUTLAND
1984, acrylic on paper, 9″ × 13″
(23 × 33 cm), private collection,
courtesy of O.K. Harris Works of Art

This small painting departs from my panoramic format and reduces the importance of the distant vista by emphasizing the geometry of the architecture. There is something very honest about this "backyard" view of a small Vermont town. The way the buildings are tucked into the foliage provides an overall sense of place without stressing individual structures.

and there is *change*. Significant growth, in life and in painting, does not happen all by itself or by accident; it happens on purpose, and it requires enormous effort and persistence. Moreover, real change is not always measurable in statistical terms. Real change is attitudinal, and it allows for a more effective relationship between a person and his or her environment.

My interaction with art over many years, and my persistence in trying to unravel the elements of its language, are finally beginning to have more tangible effects on my work. Theories that have intrigued me over the years have become integrated into my behavior as a painter and are confirmed in my recent paintings: I can see ideas slowly surfacing that were not yet manifest in the work I did years ago. My life and work have started to flow more freely, and the flow is gaining momentum.

Because painting has been such a tremendous catalyst for my personal development, I would be thrilled if, through this book, I could help someone achieve a similar kind of growth. Painting is a result of how the artist thinks and functions as a person, and I believe that to tap your talents, you must be dealing with yourself as a person.

This book, then, is a record of what I have learned. It is intended to show the important understandings, imagery, thinking, and techniques of one painter, for better or worse. I don't wish to prove anything as a writer; I wish only to share what I know about art.

In part, my aim is to strip away much of the unnecessary ambiguity of art. The language of art is much more manageable and teachable than most people think. The theories presented here are fundamental enough to be understood even by someone without a great deal of direct painting experience; at the same time, they are sufficiently dynamic to help the experienced painter reconsider the act of painting. Do not be too quick to dismiss elementary concepts just because they appear simple. Certain principles—such as those governing the dynamics of the picture plane—hold true regardless of the artist's style or skill.

The book is divided into three parts, which build on one another sequentially, but readers can also use it as a resource and refer to specific information as needed. Part One presents strategies for creating a convincing illusion of three-dimensional space and volume. It addresses a fundamental problem with most books on realist painting, which tend to overemphasize the importance of making believable images and to treat each object as a separate representational problem. Such an approach can lead to fragmented paintings; it also creates the misleading impression that realist painting is *only* about representation. My approach to representation is a spatial one, and it can be applied to any subject, regardless of specific coloration, surface textures, or other details.

Part Two focuses on how to integrate the three-dimensional illusion into a unified two-dimensional composition. Numerous visual examples show how size, placement, relative proportions, shape, light and dark values, and other components affect the overall composition. To help readers develop a critical eye, the compositional dynamics of several finished paintings are analyzed. The section concludes with a checklist, so readers can evaluate paintings more systematically on their own.

Part Three describes my working methods and somewhat unconventional ways of using acrylics, which have allowed me to develop greater skill and productivity as a painter. It also examines the overall painting process and includes a step-by-step presentation of a painting's development.

This book is written with several audiences in mind. For experienced painters, it is intended as a resource in reconsidering the fundamentals of solid realist painting. For art students, on the other hand, it may serve as a guide to the language of art. When I was a student, it was difficult to gain access to this language. I had to become my own teacher, which I did with the help of Rudolf Arnheim's books on perception. My paintings then became the laboratory in which I tested concepts. This book is an attempt to make this kind of information about art—particularly analysis and criticism—more accessible to students.

Finally, there are those who do not paint but have a strong interest in painting. This book aims to open up the visual awareness of all readers so that they feel more comfortable observing and criticizing paintings. The language of art should be as accessible to the nonartist as to someone who paints.

Each person, of course, has a specific range of interest and, for that matter, degree of readiness for the different subjects raised in this book. Not every part of the book will apply to every reader. At times, material may not apply now but may become more important in the future. Other areas may already be within a particular reader's grasp. Ultimately, the book's validity will be influenced by each reader's personal frame of reference. My hope is that its scope is broad enough to at least introduce everyone to some new possibilities.

THREE-DIMENSIONAL ILLUSION

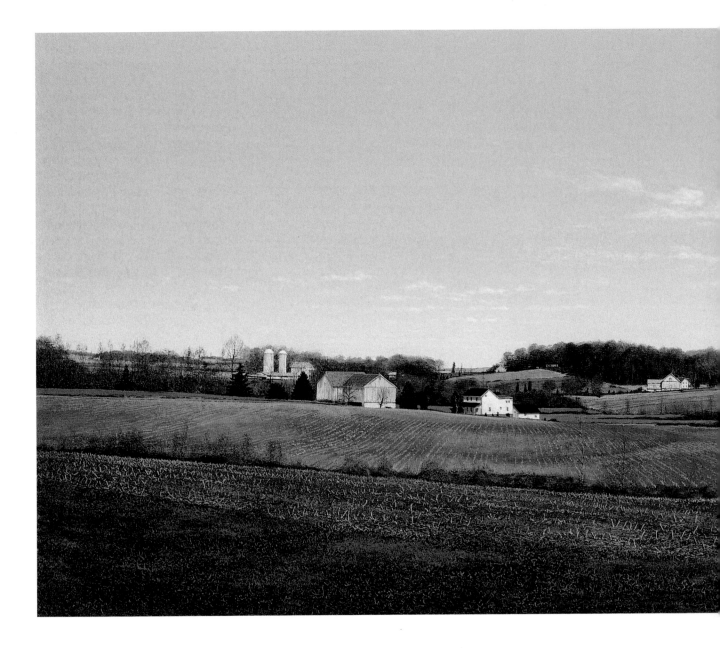

In art, describing reality goes beyond merely depicting the recognizable features of a subject. Unfortunately landscape artists often talk about painting the landscape as though it had more to do with the subject than the visual language of painting. I'm not advocating any single approach to landscape painting, but I do know that good painting is about *painting*. Successful painting requires knowledge of the picture plane, its space and its dynamics.

Whether the work is abstract or representational, the artist must know about painting before approaching the subject. At the same time, if the character of the landscape is important, the painter must know his or her subject—through touching, seeing, living in it, and responding to it emotionally—or there will be some problems. A city-dweller doing landscapes on the basis of occasional trips to the country will probably have access to only the most superficial attributes of the landscape.

This section focuses on some strategies for creating the illusion of three-dimensional space in landscape painting. Here it is important to understand the limits of the two-dimensional picture plane in describing the real world and how the language, or visual conventions, of painting can compensate for these limitations. There are many expressive equivalents for space and volume on a two-dimensional surface. Mastering them can remove a major stumbling block for representational painters.

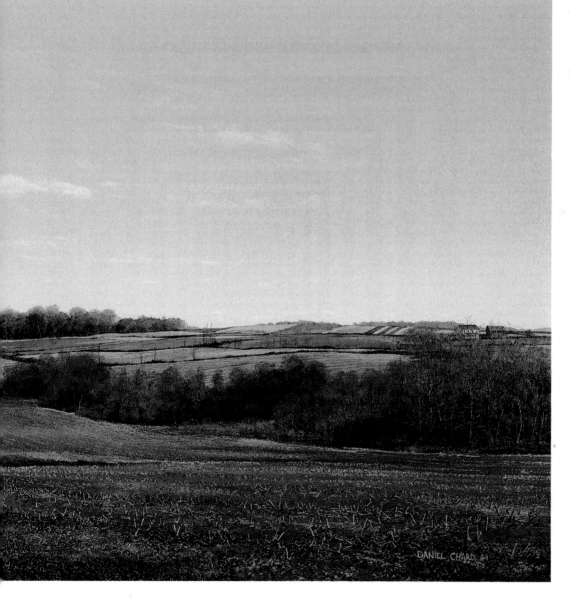

LANCASTER WINTER
1984, acrylic on board, 14″ × 30″ (36 × 76 cm), private collection, courtesy of O.K. Harris Works of Art

What is an illusion? It is a deception, like the illusion conjured by a magician. In painting, illusion is created by means of various visual tricks. The resulting image, in representational painting, often appears to be a copy of the everyday world—although we usually don't mistake the painted image for the real thing.

There are artists, however, who have made illusion a major aspect of their painting, at times even causing the viewer to make a perceptual mistake. The magic realism of William Harnett in the late nineteenth century is one example of

this. Some contemporary artists use visual illusion to deliberately trick the spectator, who may recover from the initial perceptual mistake only to experience it again—even after discovering that the painting surface really is flat.

Images that force such perceptual mistakes may be realistic or abstract, but, in either case, the space is handled in such a way that part of the painting is perceived as being separated from the surface beneath. Generally this illusion is the result of a particular use of light and shade, and it takes the familiar form of the figure-ground relationship. As de-

scribed by Gestalt theory, there is a clear, finite shape (to which we give our attention), seen against an unclear, infinite area (which is not the object of our attention). Sometimes creating an illusion comes down to crisp edges against soft edges.

Most often, though, the illusion in representational painting is a limited illusion. Even though a painting may evoke the comment, "It makes you feel as if you were actually there," there is no perceptual confusion. Such a statement simply says something about the success of the image, within the limits imposed by the two-dimensional picture plane.

It is very difficult to see this illustration as simply a series of flat bands on a two-dimensional surface. The alternating black and white stripes set up competing visual patterns. There is a shifting figure-ground relationship, as one or the other pattern competes for dominance. Also notice how the diminishing width of the bands produces a "tunnel" effect and a strong illusion of three-dimensional space.

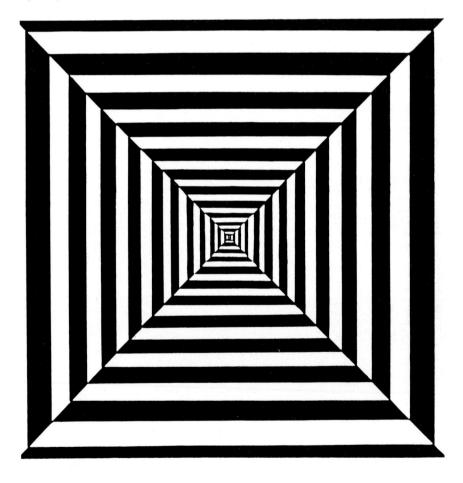

ANALOGOUS IMAGERY

A limited illusion in painting should generally present enough information about the subject for the image to be considered a faithful visual analogy (from a single vantage point), without attracting attention to the devices used to manufacture the image. This kind of illusion, it should be noted, is a means toward some aesthetic end; it is not usually the objective of the painting.

A faithful visual analogy, by the way, does not say anything about the process the artist used. When a painting looks convincing, people often assume that the image has been copied. But, without knowing the painter's original sources, how can we even discuss copying? Often a realist painter corrects or changes visual information from photographs or other sources to make the image more effective. Although the imagery may appear highly realistic, it is a translation rather than a direct copy of the original subject.

At times realist painting may actually involve exaggeration or distortion. The question to be asked is: Does this indicate a lack of control, or is it deliberate? All too often exaggerations in student work are celebrated as expressionistic by their teachers. Although these images may create psychological tensions and evoke feeling in the spectator, the distortions will be more effective if they are a purposeful, controlled departure from solid draftsmanship.

I believe that developing imagery is about control and discipline. Too often, weak imagery is due to poor observational skills. The result is a simplistic, conventional interpretation of the subject, involving symbolic imagery rather than a more descriptive analogy. Instead of developing the texture and subtle color of grass, for example, a painter may rely on a strong green to carry the idea of grass. Unless the painter is trying to emphasize flat space (as Henri Matisse did), the painting will reflect poor observational skills.

Developing one's observational skills is not as straightforward as it may seem. Often, our knowledge of the subject influences the way we see it. Everyone who tries to paint effective analogies will encounter some difficulty with objectivity. A good example is the discrepancy between our actual perception and our conception of a tabletop (see the illustrations on page 18).

SPEARFISH CANYON—MORNING
1982, acrylic on paper, 7″ × 16″
(18 × 41 cm), private collection,
courtesy of O.K. Harris Works of Art,
photo by Benjamin Fisher

To describe the look of my paintings, I often use the term "clear-image realism." This term refers not to the structural features of my painting, but to the faithfulness of my visual analogy and to the technical means that support the analogy.

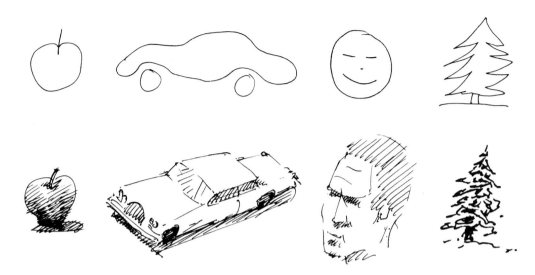

Symbolic images are simplistic, presenting only the most general and superficial aspects of the subject. As a symbol, the car here could be even simpler—an oblong shape with two circular shapes beneath it.

Analogous shapes are more complex than symbolic ones. They usually show more of the object's volume and give some indication of light and dark. Notice how the patterns of line imply shadow, while what is not drawn—the white spaces—imply brightness.

OBJECTIVITY EXERCISE

To test the accuracy of your spatial perception, stand about thirty feet from a table that is perpendicular to your line of sight. Try to guess the distance from the front edge of the table to the back edge, and compare that distance to the full width of the table. After determining this ratio, measure the relative height and width of the tabletop, as illustrated, by holding a pencil at arm's length. The results of this exercise are usually surprising. Most people tend to underestimate the extent to which an object is foreshortened, and when they try to draw it, their drawings often reflect a compromise between what their eyes see and what they know about the object.

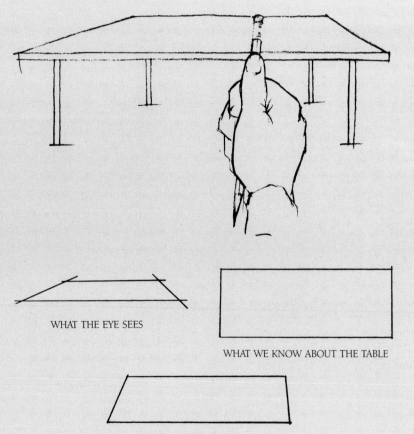

WHAT THE EYE SEES

WHAT WE KNOW ABOUT THE TABLE

COMPROMISE DRAWING OF
TABLE IN PERSPECTIVE

A STRATEGY
FOR REPRESENTATION

In describing three-dimensional images realistically, the artist must use strategies to compensate for the limits of the two-dimensional picture plane. Often there is a tendency to characterize some of the major features of a subject, but to give up before organizing these features from major to minor. What effective representation requires is a careful organization of shapes and patterns. Essentially there is no real illusion in representation—it is just shape and pattern.

The trouble is that once we recognize an object—such as a tree or grass—we tend to stop looking at it critically. Instead of thinking about a tree or grass, a representational painter must try to study the different shapes and patterns as objectively as possible. Volume, orientation, location in space, and configuration are all important considerations in relation to shape. Particular attention should be paid to the suggestion of volume at the edges of a shape. In terms of the patterns within the shape, one should examine their character, size, direction, density, contrast, transition, homogeneity, complexity, and structure (see the illustrations on pages 22–23).

In general, the patterns within the shape, describing its surface, should be kept subordinate. Specifically, the value contrast between the shape and its surroundings should usually be greater than the contrast within the shape. Of course, coordinating various combinations of shapes and patterns requires a lot of practice, but eventually this can become an automatic part of the painting process.

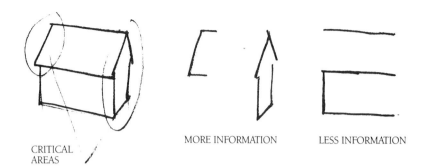

CRITICAL AREAS

MORE INFORMATION

LESS INFORMATION

In a foreshortened object, there are critical areas that indicate its exact location and volume. Other areas—such as the flat front wall of the house here—are less critical in making the volume convincing.

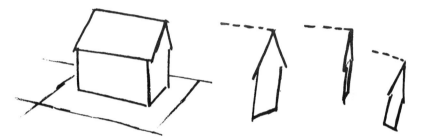

The way a shape is represented can establish its orientation to the viewer. Note that a strongly foreshortened view adds more energy to the illusion than a view of the subject parallel to the picture plane.

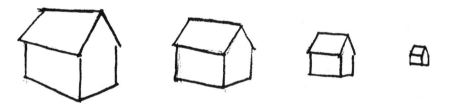

Distance from the viewer can be determined from an object's relative size.

The definition of the configuration is too often generalized. Specific attention to all the details can make the volume more convincing.

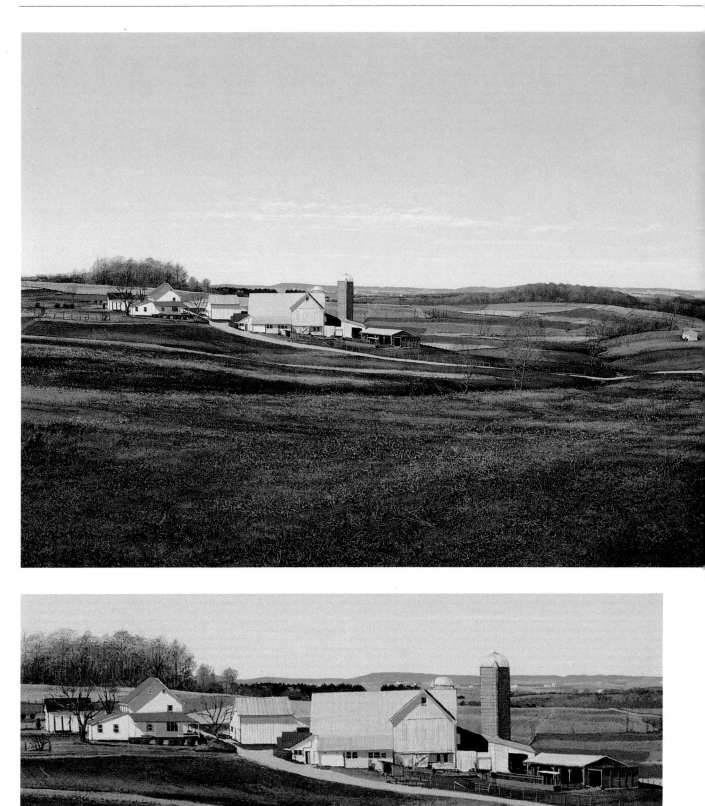

Compare the front barn with the house and notice the difference the angular view makes in suggesting volume.

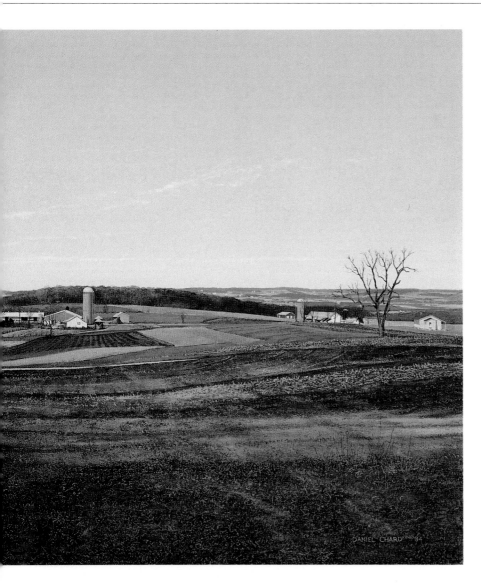

SAWMILL ROAD
1984, acrylic on board, 16½″ × 36″
(42 × 91 cm), private collection,
courtesy of O.K. Harris Works of Art,
photo by D. James Dee

*The illusion of grass or water or wood has a lot
to do with the characteristics of the internal
pattern. It may be helpful at first to study these
patterns in photographs and paintings, as a
way of learning how to translate the subject's
visual properties.*

*Instead of just resorting to green paint for
grass, one must come up with brushwork
related to the particular characteristics of the
subject. Compare this detail of grass with the
patterns on the next two pages.*

A painter must constantly observe patterns and notice differences in character (regular or irregular shapes), size (large or small), direction, density, contrast, transition, homogeneity, complexity, and organization. The examples here suggest just a few of the many possibilities.

1.

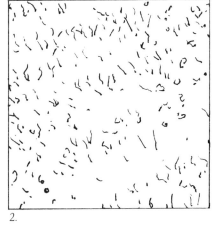

2.

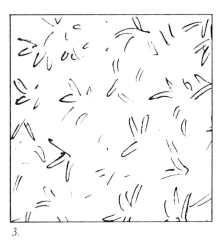

3.

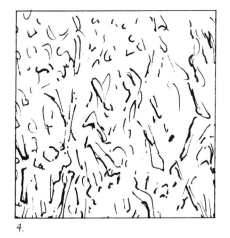

4.

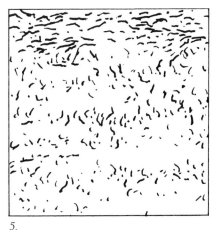

5.

6.

7.

8.

9.

1. From Deadwood *(page 49).*

2. From Spearfish Canyon—Morning *(page 17).*

3. From Brick House *(pages 96–97).*

4. From West Rutland *(page 12).*

5. From Cheney *(page 65).*

6. From Horsethief Canyon *(page 8).*

7. From Lancaster Winter *(pages 14–15).*

8. From Spearfish Canyon—Morning *(page 17).*

9. From White House Wall *(pages 68–69).*

In using realist imagery to communicate an idea or experience, the painter is involved in manipulating the viewer's expectations. One source of these expectations is our experience with photographs. In many ways the dominance of photography has set the standard for realist imagery today—even more so than the actual appearance of the world around us.

Another source of our expectations has to do with the way we function spatially in the real world.

Our major senses are primarily spatial, informing us about such spatial properties as scale, interval, frequency, intensity, and contrast. As bipedal creatures, we also have a keen sense of balance.

A disturbance in the expectations of our senses can be downright disorienting. Some amusement-park rides, for example, deliberately manipulate our spatial mechanisms, playing on the inner ear's response to the pull of gravity and the eye's search for a vertical orientation. A

fast elevator, a roller coaster, a downward view from a tall building, and a confining cave can all be sources of spatial disorientation.

Film is an example of an artistic medium that can provide actual, if only momentary, disorientation, because in the darkened movie theater we actually orient ourselves to the screen. A film of a roller-coaster ride or a screen image that turns upside down (as if seen from a rolling airplane) pulls at our visual orientation even though the inner ear's

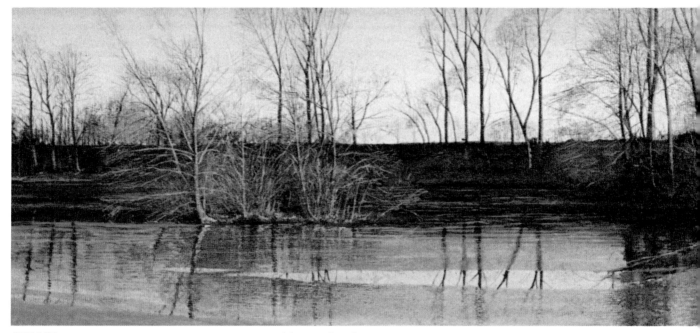

CAT ICE
1980, acrylic on paper, 3″ × 13″
(8 × 33 cm), private collection,
courtesy of O.K. Harris Works of Art
(reproduced larger than actual size)

Certain aspects of this scene have been amplified to provide perceptual cues. Specifically, the freshly formed ice has been exaggerated at the water's edge and the coloration of the reflections on the water and ice has been varied to give a convincing representation of "cat ice" (a thin ice that looks deceptively solid). Manipulations like these build on our expectations and help to make the painting more believable.

balance mechanism is not disturbed.

Unlike a film, a painting is a static image. Moreover, when we look at a painting, we are spatially oriented to the room in which it hangs. So a painting has little potential to disorient us physically. Nevertheless, by manipulating the visual field, a painter can manipulate our visual perception and therefore our experience. That is why it is useful for artists to learn about the psychology of perception.

The way we attribute gravity to the picture plane is one example of human spatial capacities at work. Objects on the picture plane appear to be affected by the force of gravity. Another example of our spatial capacities is our keen ability, as bipedal beings, to discriminate a variation from the vertical (more so than a variation from the horizontal). The picture frame serves as the limit for these experiences, containing the various perceived forces within its boundaries. Its importance as a frame of reference cannot be overestimated (see also page 53).

My emphasis here on a spatial approach to painting should not seem too far off the beaten path. Other art forms, including dance, music, and theater, are in large part based on spatial phenomena. In general, the language of the arts reflects human spatial functioning—something we respond to intensely. A closer examination of why we respond to visual phenomena can provide a better understanding of effective composition.

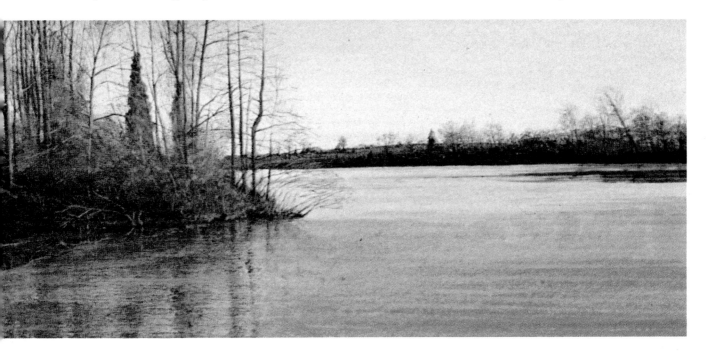

THE VOLUME
OF THE PAINTING

In developing the space within a painting, the artist must consider not only the three-dimensional illusion of depth but also the implied volume of the landscape. It may help to think of the landscape volume as a box defined by the picture frame. Although the two-dimensional design of the painting is important, the viewer's eye should move not only around the two-dimensional surface, but also through the illusory three-dimensional space and around the objects within it, just as though it were real space.

The volume of the three-dimensional space may become more apparent if one thinks of the landscape as a horizontal plane bounded by the picture frame.

These drawings of the spaces in two of my paintings show different concepts of landscape volume. Woodstown has a relatively shallow space and thus a limited volume, while Dirt Road has a deep space, with maximum volume.

WOODSTOWN (see page 127)

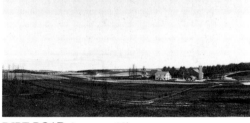

DIRT ROAD (see page 82)

These two diagrams illustrate the difference between two-dimensional composition and three-dimensional spatial illusion. In the first illustration, the arrows indicate the visual movement on the two-dimensional picture plane. In the second, the arrows show how the three-dimensional illusion of space moves the eye around positive volumes and through negative volumes.

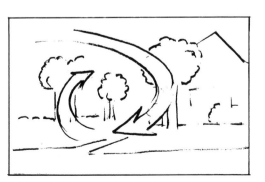

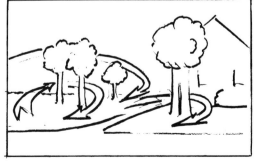

Often one of the first considerations in designing a landscape painting is the relationship between sky and ground. Our expectations contribute to our ability to discriminate between the two. Even the most rudimentary indication of a sky-ground relationship implies a gravitational pull toward the bottom because of our vertical orientation as human beings. We always expect the ground to be the bottom and the sky to be the top portion of the painting.

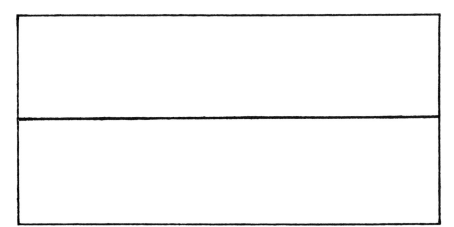

A simple horizontal division of a rectangle immediately implies a sky-ground relationship.

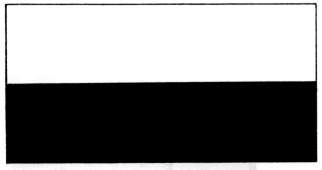
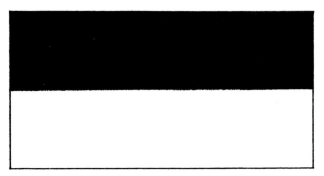

Adding contrast does not alter our inclination to see a sky-ground relationship in the horizontal division of the picture space.

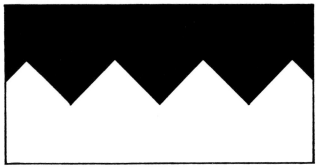
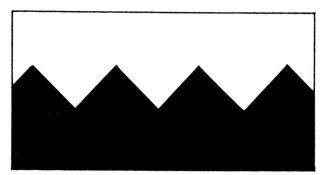

Combining contoured shapes with contrast still shows the sky-ground tendency.

To understand the effect of gravity in a painting, look at the various illustrations on these two pages. The implied gravitational force lends weight to areas at the bottom. If the artist then develops these areas in such a way as to create an illusion of mass or density, they acquire tremendous weight.

The gravitational pull on an object is affected by its location within the painting. Notice how strongly these shapes are pulled toward the bottom when they are located in the upper portion of the frame.

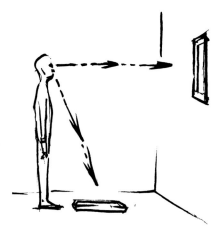

A painting generally carries a sense of gravity when it is viewed on a wall, but it loses this pull when viewed on the floor.

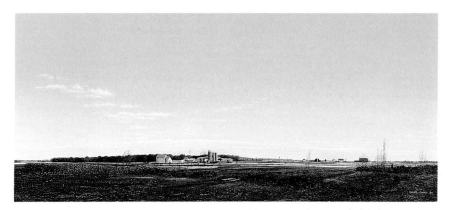

WHIG LANE
1984, acrylic on paper, 15″ × 33″ (38 × 84 cm), private collection, courtesy of O.K. Harris Works of Art, photo by D. James Dee

Whig Lane has a strong feeling of gravity, which becomes even more apparent when the painting is viewed upside down.

The tautness of the horizon line can be used to communicate something about the volume within a painting. A tightly drawn horizon (top), as opposed to a more loosely structured one (below), implies a greater gravitational pull, as if everything were pulled against the earth's surface.

LAKE BOMOSEEN
1982, acrylic on paper, 12″ × 19″ (30 × 48 cm), private collection, courtesy of O.K. Harris Works of Art, photo by Benjamin Fisher

Here the water's edge creates a taut horizon line. The incremental decrease in the pattern of waves moving toward the horizon reinforces its tautness.

THE HORIZONTAL PLANE AND PERSPECTIVE

The horizontal plane—or ground plane—serves as a structural shelf in a painting, providing underlying support for the three-dimensional illusion. In defining the horizontal plane, moving from foreground to background, the artist is also defining the space above and around that plane—the entire volume of the painting. In other words, the clearer the definition of this plane, the greater the implied volume of the space.

An important consideration is the location of the horizon line, as this affects how the viewer sees the three-dimensional illusion. By manipulating the horizon line, the artist can control the tilt of the ground plane, influencing the perception of both distance and volume. A related concern is how close the foreground comes to the spectator.

In addition to setting the viewer's vantage point, the tilt of the horizontal plane can show a kind of energy in itself. A good example is a greatly tilted plane—as in an aerial view—which shows many different shapes.

Yet another consideration is perspective. Looking at the horizontal plane in perspective can raise one's consciousness of how that plane should be treated. But linear perspective should be used only as a way of planning and as a problem solver; it should not become an end in itself. Convincing realism requires an emphasis on value as well as planes. Defining volume by describing planes with values can help organize the space and produce a more analogous image.

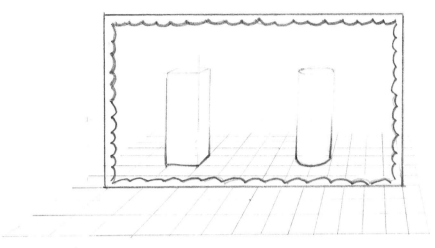

To define the volume of the painting space, the horizontal ground plane can be treated as a grid. The artist can also use this grid to give shape to the bottom edges of individual volumes.

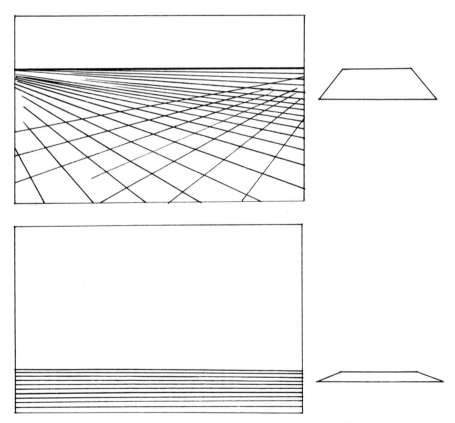

A subtle but important feature of the ground plane is its tilt from the foreground to the horizon. These are two different ways of visualizing what it means to tilt the ground plane, which is primarily represented by a low or high horizon.

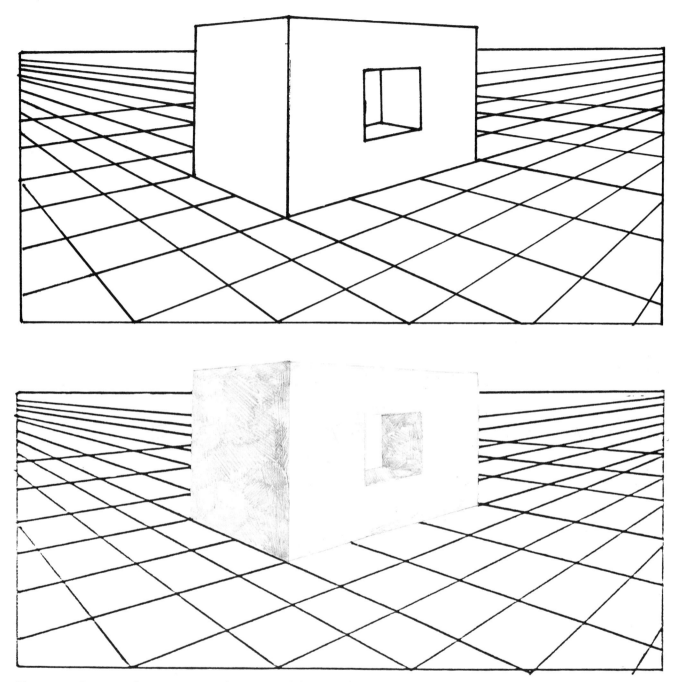

Linear perspective may involve one or more vanishing points, and their location on the picture plane may vary. Just drawing the lines of perspective, however, provides only a limited analogy to the actual appearance of things, unless care is also taken to emphasize the planes of volumes tonally.

CONTOURS

The three-dimensional illusion can be strengthened by considering the contours of the horizontal plane, including unseen volumes behind hills and stands of trees. Specifically, the edges and textures of the subsidiary planes carry the sense of volume.

ANGULAR FIELDS
1984, acrylic on board, 14½" × 31" (39 × 79 cm), private collection, courtesy of O.K. Harris Works of Art

In nature, the horizontal plane of the earth is rarely perfectly flat; there are usually at least some surface irregularities. This illustration shows how an irregular horizontal plane could be thought of as part of the painting's volume. Textures and patterns can reinforce and clarify surface variations.

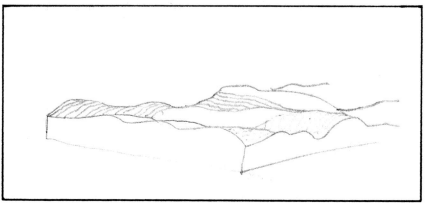

Variations in the ground plane can be structured so that they progress from major to minor, in order to help organize the illusion of depth and provide continuity. Angular Fields is a good example of this.

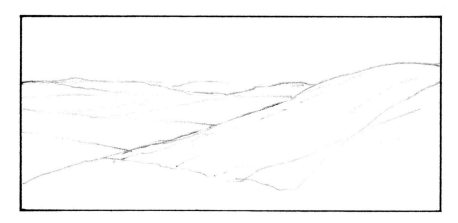

THE HORIZON LINE

There is a tendency for artists to generalize the horizon line, but it should be treated with care. If the horizon line is clearly defined, it can enhance the illusion of space. In particular, it can make the sky seem softer and more atmospheric, so that the sky seems to go back behind the ground.

Too much emphasis on the horizon line, however, can make it advance toward the foreground, thus flattening the horizontal plane. A good way to avoid such a contrasting horizon line is by a thorough development of the ground plane, from the foreground to the background. The definition of the horizon's edge should show natural diversity and imply the continuation of the ground beyond, to infinity.

Keep in mind that the horizon line often provides the major division of the picture plane. If the sky can be seen as a positive space compositionally, it will provide strength and stability to the picture.

Placing a painting on end allows one to isolate the shape of the horizon from other shapes more easily. In Valley, *notice that the shape of the horizon includes the building and makes the sky-ground relationship very graphic.*

IRA (see page 93)

VALLEY (see pages 70–71)

Often the horizontal ground plane can be seen as containing subordinate planes with various organizational characteristics. They can be shaped and grouped to enhance the illusion of space, to help organize the composition, and to create overall interest in the image.

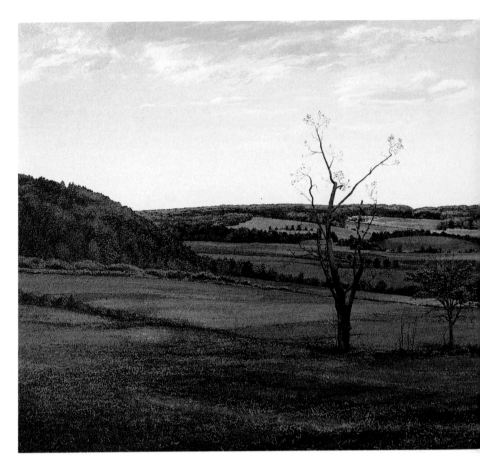

CLOUDS AND SHADOWS
1983, acrylic on paper, 8″ × 22″
(20 × 56 cm), private collection,
courtesy of O.K. Harris Works of Art,
photo by D. James Dee

The horizontal plane can be defined as a series of interrelating planes. My painting Clouds and Shadows *and the accompanying diagrams illustrate how the development of these planes can both structure the horizontal plane and contribute to the overall character of the work.*

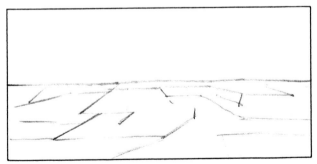

This arrangement is relatively simple, with its interest deriving from its angularity.

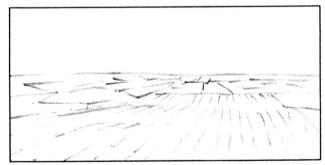

Unlike the two examples to the left, this subdivision of the horizontal plane involves a strong perspective moving toward a focal point.

This division of the horizontal plane emphasizes the horizon line and promotes a sense of distance and scale.

Subdivisions within the horizontal plane can be shaped and arranged in such a way as to establish focal points.

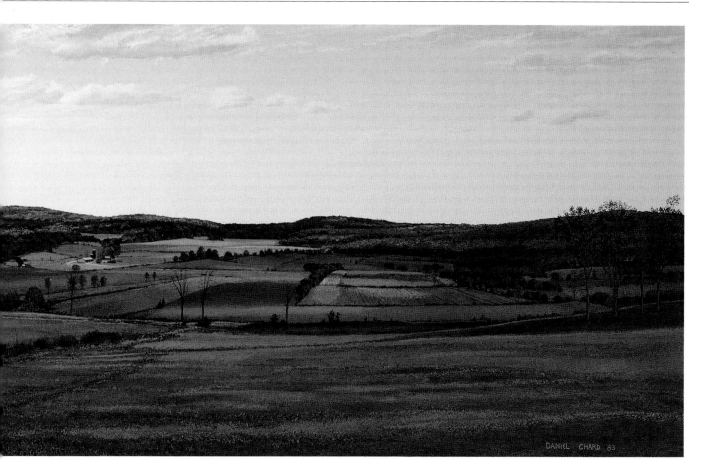

The subordinate planes can be treated independently as shapes in their own right and reshaped to better support the three-dimensional illusion of the ground plane.

Planes can be organized so that they correspond with the painting's frame and are more or less contained within the overall image, or they can extend beyond it.

Subordinate horizontal planes should be considered in terms of their degree of foreshortening, almost as if they were the top planes of separate foreshortened objects. It is important to understand what happens to the shape of a plane when it is seen in perspective.

When subordinate planes are given tone and texture, the horizontal plane begins to take on an overall design or pattern.

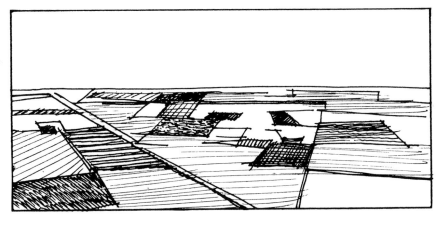

The overall pattern of the ground plane can be approached as a design problem.

Individual shapes can have energy: they have their own internal dynamics, and they also push against one another. The energy forces of individual shapes pushing against one another can create counterpoint within the design of the horizontal plane.

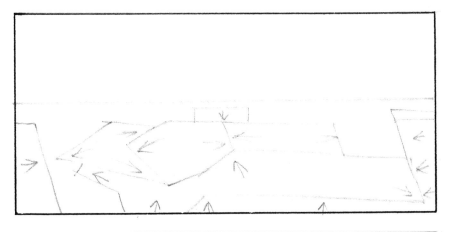

Although the introduction of stands of trees here hides part of the horizontal plane, it is still implied.

SURFACES
AND EDGES

The internal development of the painting—including the description of surfaces and edges—increases the spatial illusion. The description of grass or water, for example, can be particularly useful in defining the volume of the space. Again, it is important to observe the different patterns accurately.

Attention to the edges is equally important. The edges can indicate how the surface ends, changes, or approaches another surface. Often the edge provides the best opportunity to show the textural character of the surface—for example, depicting a shadow on grass or the contrast of grass against a sidewalk.

These drawings and those on the next two pages show some of the different characteristics of the horizontal plane and how it can be developed to direct the eye.

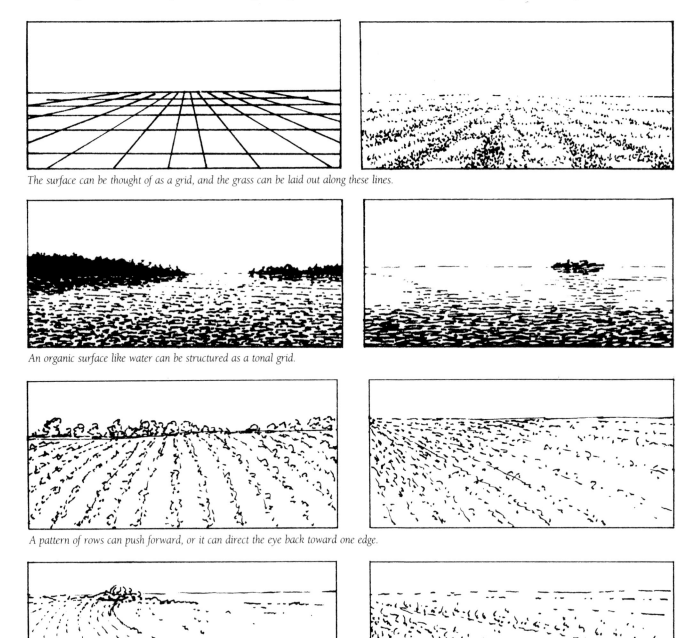

The surface can be thought of as a grid, and the grass can be laid out along these lines.

An organic surface like water can be structured as a tonal grid.

A pattern of rows can push forward, or it can direct the eye back toward one edge.

Both these patterns direct the eye to the left.

The various characteristics of pattern such as size, direction, and density (mentioned on pages 22–23) must all be considered in developing the horizontal plane.

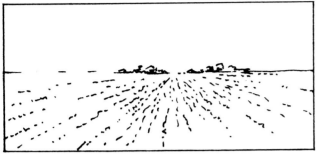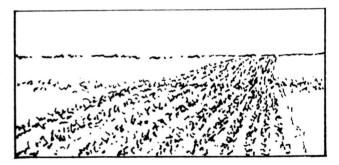

The direction of the pattern can establish focal points.

There can be a merging of different patterns.

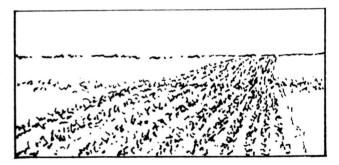

A counterpoint may be created when patterns run in conflicting directions.

The surface may be finely textured or dense with growth.

*Edges and shadows can be used to define the horizontal plane, as
indicated in these illustrations.*

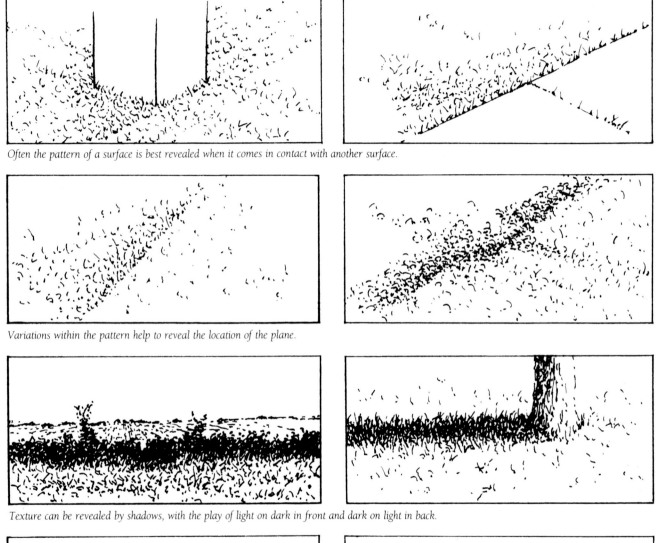

Often the pattern of a surface is best revealed when it comes in contact with another surface.

Variations within the pattern help to reveal the location of the plane.

Texture can be revealed by shadows, with the play of light on dark in front and dark on light in back.

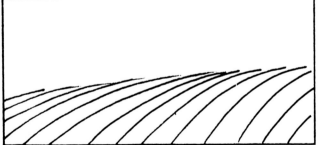

The lines of a pattern should converge at the edge of a hill to show its continuation beyond our line of sight.

OBJECTS AS VOLUMES

An important part of the volume of the space is, of course, the volume of the objects themselves. In general, the objects should sit on the horizontal plane. A sound strategy for developing an object's volume is to draw its base on the horizontal plane. Another factor to consider is the angle of the object, as some views present more information than others (see page 42).

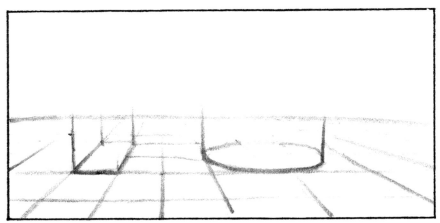

To develop volumes that sit convincingly on the ground plane, one must consider the bottom of the shape as it makes contact with that plane.

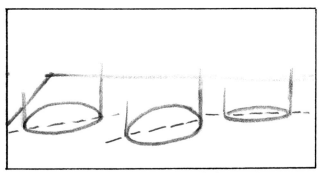

These bases seem to tilt toward or away from the horizontal plane.

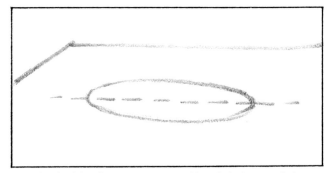

Here the tilt of the ellipse is more compatible with the horizontal plane.

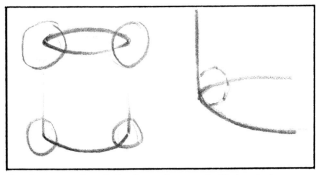

It is the corners of a cylinder that really carry the illusion. At these points, the vertical merges into the circle, or ellipse.

The tendency is to make the transition either too sharp or too soft.

VOLUME CONCEPTUALIZATION EXERCISE

This exercise is intended to develop artists' skills in visualizing an object from any angle, so that they can conceive its volume and manipulate it to achieve the best representation of it. Practicing this not only provides better control in one's paintings but also enables one to think through a representational problem without even making a mark on the painting surface.

In the first example, the letter *N* has been depicted as a three-dimensional volume from three different views. Each view lacks some critical information available in the other views, so one has to combine all three views to "see" the whole volume. In each view the dotted lines represent the edges one would see if the planes were transparent.

Practice your visualizing ability with the other three examples here. Can you understand the volume without drawing it? For the solutions, turn to the illustrations on the next page.

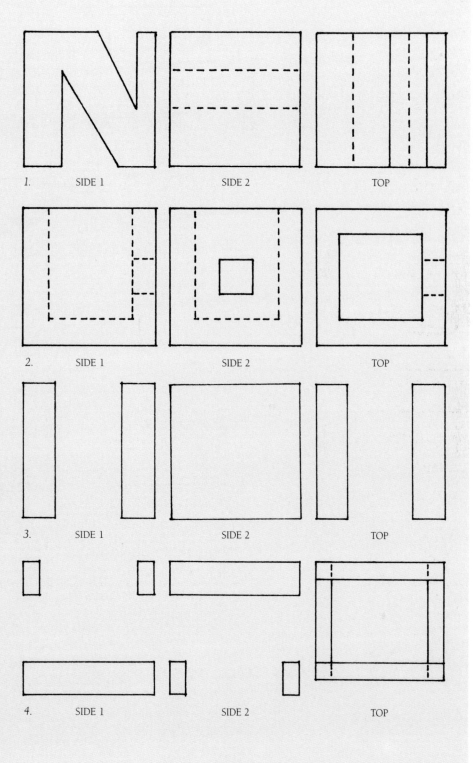

1. SIDE 1 SIDE 2 TOP

2. SIDE 1 SIDE 2 TOP

3. SIDE 1 SIDE 2 TOP

4. SIDE 1 SIDE 2 TOP

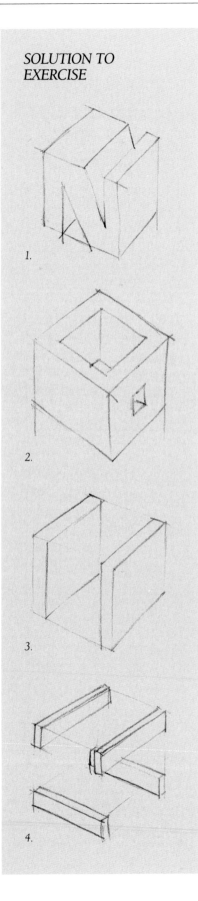

SOLUTION TO
EXERCISE

1.

2.

3.

4.

As noted earlier, some views of an object provide more information about it than other views do. Here the progression is from the least to the most favorable view in terms of a convincing volume. Notice how much the angular perspective and shadows contribute to the illusion.

When cropping an object that extends beyond the picture frame, it is best to first draw it in its entirety, extending it beyond the edges. Its volume will be described more convincingly if all the information has been considered.

THE INTERVALS BETWEEN OBJECTS

Often the suggestion of negative volume, or the space between objects, is the result of default—whatever is left over in the painting process. There are, however, ways to structure and amplify these intervals to enhance the three-dimensional illusion. Tilting the horizontal plane or using an angular perspective can clarify the negative volume while making it more dynamic. Overlapping and contrast are additional ways of defining the intervals and making the overall volume of the space convincing. Finally, with experience, subtle mixtures of values and colors can be used to augment the intervals and volume.

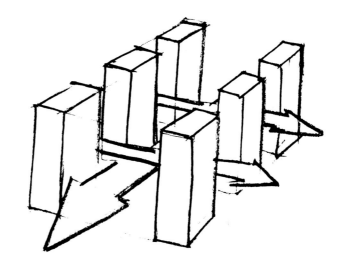

To create a three-dimensional illusion, one must develop the intervals—or negative volumes—between the positive volumes.

A gridlike development of the horizontal plane can indicate the distance between objects. Texture or pattern can also be used to define the interval.

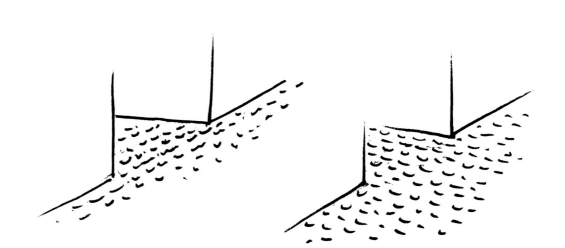

Tipping the horizontal plane on which the objects rest can clarify the intervals between them.

Changing the positions of objects within the frame can also clarify the intervals between them.

Overlapping, differences in size, and angular views can all help to imply volume and three-dimensionality.

Value contrast can help to create a stronger illusion of space between objects.

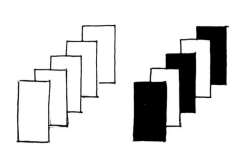

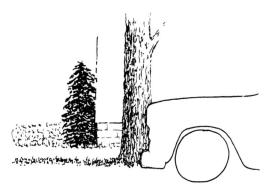

 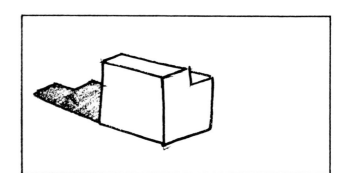

The shadow that an object casts can provide information about its volume that is not obvious from its shape alone. It can, for example, reveal the shape of the blind side. Also note that, because the cast shadow must conform to the ground plane, it reveals the tilt and contours of that plane.

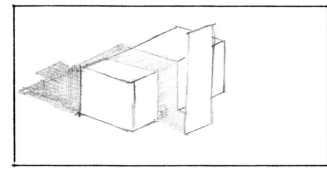 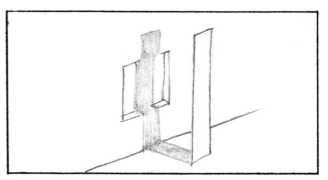

On the left, the cast shadow conveys the density of the stand of trees, while on the right it reveals the texture of the ground plane.

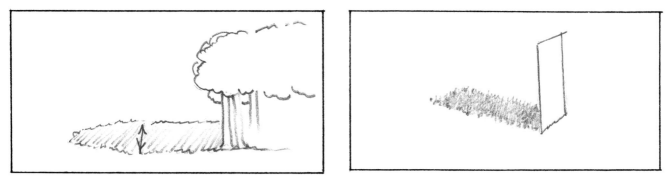

A cast shadow conforms to the surface on which it falls, revealing the shape of that surface. It can also help to define the interval between objects.

The location of the shadow in relation to the object implies something about the object's location in space, as can be seen by comparing these two illustrations.

PART TWO

COMPOSITION

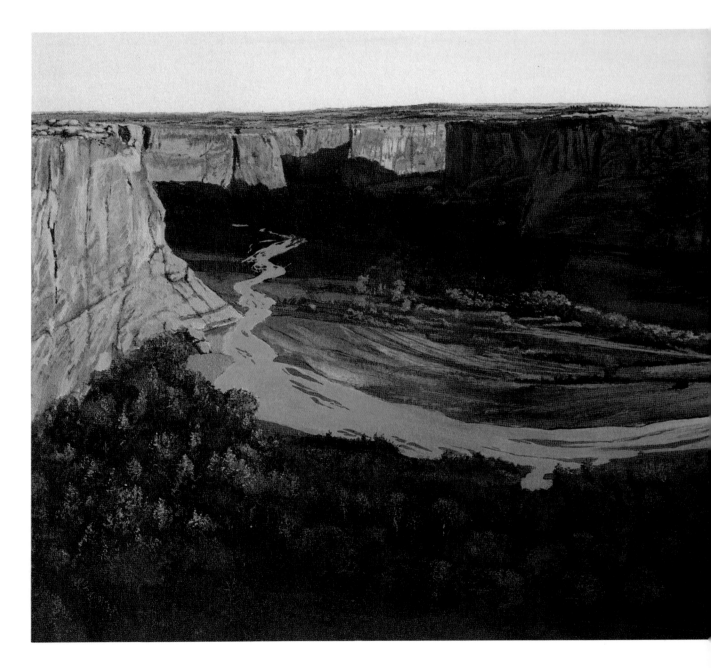

ompositional skills are critical for the expression of a painter's visual ideas. Yet, because of our expectations of realistic imagery, it may be easier to recognize problems with draftsmanship in a representational painting than problems with composition. Moreover, a lack of painting facility can be a major impediment to the development of compositional skills. Inexperienced realist painters may be so preoccupied with making the subject believable that they fail to develop effective compositions. Indeed, unless an artist has achieved the ability to create analogous images with almost the same ease as writing a letter home, it is difficult to arrive at sophisticated compositions. That is why the first part of this book was devoted to repre-

sentational skills. For the goals of painting to become compositional, the rest of the painting process must be fairly automatic, much like playing a musical instrument with great dexterity.

Learning to represent the real world convincingly is thus merely a beginning. The next step is discovering how to integrate the three-dimensional illusion into the overall two-dimensional design. In focusing on composition, this section presents different ways of organizing visual information on the two-dimensional picture plane. It includes detailed analyses of several finished paintings and concludes with a checklist of things to look for when studying either your own paintings or the work of other artists.

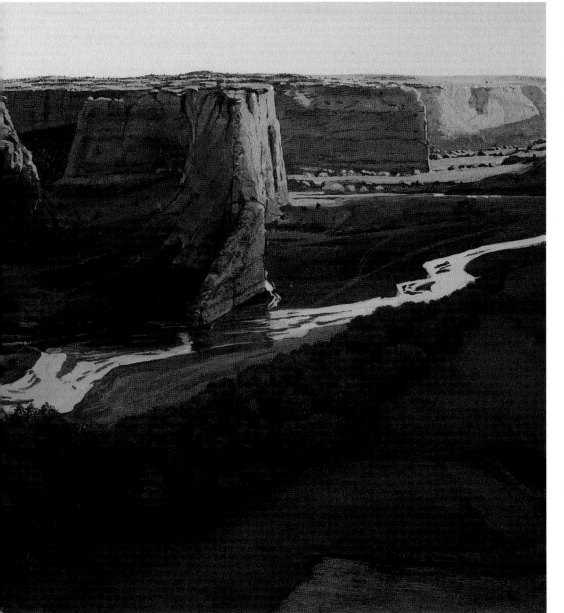

CANYON DE CHELLY—NORTH
1983, acrylic on paper, 7″ × 16″ (18 × 41 cm), private collection, courtesy of O.K. Harris Works of Art, photo by Benjamin Fisher

THE IMPORTANCE OF COMPOSITION

What is composition? Essentially composition is a means of organizing the space of a painting and expressing its objectives more clearly. A great composition compels you to keep looking. It adds a dimension to the painting, making it seem inexhaustible, as if it were living and breathing; the painting seems to come to life when you perceive it. The painting's complexity does not allow you to "consume" it right away, tire of it, or dismiss it—instead, it retains a compelling sense of mystery. It is impossible to pin this effect down to a formula or a single explanation—that would be to reduce a good painting to something ordinary. It is dynamic.

Although composition is probably the biggest challenge to a painter, it is not a "craft" that can be easily taught. Throughout art history, it has largely been composition that has separated the masters from the academics. The academics studied the masters, took in what was known, and became proficient at the craft of painting. They could imitate the masters' general approach to subject matter, color, and so on, but could not equal them in the area of composition. The imitators understood that the masters had something special when it came to composition, but they did not know how to go about creating their own good compositions. The frequency with which great compositions were copied by others indicates this.

None of this is meant to be discouraging. It is just that composition is one of the areas where artists have shown the least originality. There are, however, strategies for developing compositional skills, some of which are illustrated on the pages that follow. But keep in mind

that not all the answers are in this book, or in any single book or art course. To build a basic foundation of understanding of composition, you have to begin with your own eyes and study composition by looking at many paintings.

Which paintings should you look at? It is best to start with paintings that have held up through the centuries, ones considered important by general consensus. As already noted, Rogier van der Weyden is the artist who has had the greatest effect on me because of his original, complex, and dynamic compositions. But I also refer to Caravaggio, Rembrandt, Vermeer, Ingres, Degas, and Eakins in reconsidering where I want to go in my own painting. In a more expressive vein, I might look to Delacroix and Géricault. By studying the works of artists like these, you will become familiar with good compositional solutions. These artists demonstrate what is possible. And, at some point, after you have begun to develop your eye a little more, differences in compositions will become apparent.

Along with looking at paintings, it is helpful to do some reading about perception and design. Again, I especially recommend Rudolf Arnheim's books on the psychology of perception. A few art theory books provide informative discussions on the compositions of paintings. I have also found some books with a Gestaltist approach to music theory that have helped me understand art theory.

In addition to reading and looking, artists must practice compositional techniques. A good way to develop spatial awareness is by working with pure design problems. (The years I spent working with pure design problems in my abstract

paintings, for example, were of great benefit to me when I returned to realist painting.) Finally, it is important for artists to develop facility with their medium and good draftsmanship so that compositional ideas flow easily.

Composition should be an integral part of the painting process. Too often, artists wait until the end of a painting to approach compositional issues with specific strategies—looking for ways to create balance or to "pull it together." At this stage, however, it is too late to resolve major compositional problems. They must be dealt with from beginning to end, throughout the painting process.

All this does not mean that composition is an entirely conscious process. The more one studies, the more one changes the way one sees, so that eventually compositional decisions become automatic, or intuitive. It takes a lot of study, however, to effect real change in one's painting behavior.

In a sense painting is a process of turning oneself loose. In the beginning there may be conscious decisions to be made about structure, in order to find a simple way of integrating the image. But once this direction is taken, all that may be needed is a policy of internal consistency, supporting the basic spatial concept without much conscious effort. The power of the unconscious can be allowed to take over. Deliberate corrections may be necessary later in the painting process, if something detracts from the compositional idea. Once the painting is underway, however, it takes on its own life, asserting its own logic, unlike that of any other painting. The artist should let the painting go in that direction.

RELATIONSHIPS AND EMPHASIS

An understanding of composition begins with a recognition of the interrelatedness of all the parts of an image, and of the effect of each part on every other part. Merely being able to describe a particular object within a larger image has no value in and of itself. Things do not exist in isolation. It is the total context that is important. The characteristics of any object—such as its weight, shape, size, and temperature—depend on its surroundings. The language of painting is *relational*. To ignore the impact of the overall context is to ignore what unifies the image and gives it sense; whether we like it or not, the interrelatedness of things is there.

The artist may emphasize or de-emphasize various parts of the image to direct the viewer's attention and create focal points. One kind of emphasis occurs in illustrative imagery, which uses exaggerations in storytelling for a direct and immediate impact on the spectator. N. C. Wyeth's paintings are a good example. In sophisticated paintings, however, the emphasis may not be so obvious. Indeed, the viewer may be led back to the painting again and again because the artist's means are subtle and not so easily understood.

In creating emphasis it is important to deal with the total context rather than just with the object or area to be emphasized. Something becomes the object of our attention because it differs in some way from its surroundings. Often, the more complex and subtle the relationship between the thing and its surroundings, the more interesting the painting. The whole idea of a painting might even be based on this relationship.

Put another way: it is the supporting background that provides the context for a great painting. This understated network of lines and shapes allows the main features of the image to be seen most effectively.

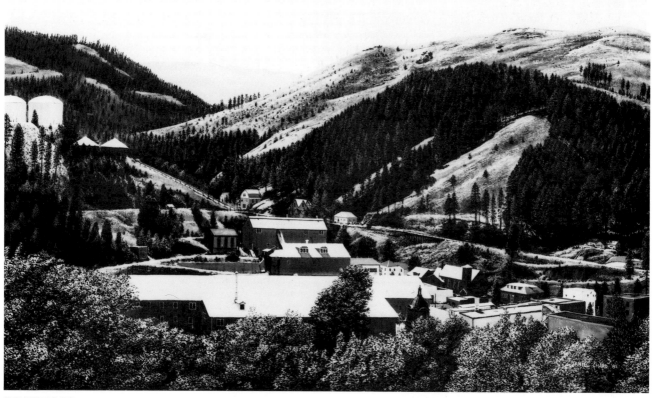

DEADWOOD
1982, acrylic on paper, 12″ × 19″
(30 × 48 cm), private collection,
courtesy of O.K. Harris Works of Art,
photo by Benjamin Fisher

Responding fully to a painting involves a lot of looking and an awareness of a variety of features in the work. With Deadwood, for example, one might begin by observing the sequence of overlapping forms, from the foreground trees to the buildings to the mountains. Next one might notice how the painting's organization comes from the architecture and how the diagonals in the mountains form a "sunburst" composition, with lines radiating from the center. Then one might step back to look at the painting without any particular focus, taking it in as a whole.

THE STRUCTURE
OF THE RECTANGLE

The manipulation of space within the two-dimensional picture plane is the essential compositional problem for the painter. The first aspect to consider is the rectangle that defines this picture plane. It is a finite shape with two sides parallel to the horizon and two uprights, perpendicular to the horizon. It is as stable as a post-and-lintel architectural construction and has similar dynamics.

To understand these dynamics, think about the force of gravity on a rectangle on the wall and consider the visual pressure of the topmost horizontal on the supporting verticals. There would be differences in this pressure with a panoramic rectangle, a square, and a vertical rectangle. It appears to take the most strength to support the cross-beam, or lintel, when the rectangle is elongated vertically because there seems to be greater gravitational pull on this horizontal; the other types of rectangles are less energetic.

Another way to think about the rectangle is as four connected points. Its corners are connected not only through the perimeter, but also through the implied diagonal, so that each corner is connected to the other three. While the diagonal "lines" are not tangible like the perimeter, they are nonetheless perceived as structural supports. Because of this, objects placed along the diagonals appear to be more stable.

Emphasis on the diagonals can produce a great deal of energy because they represent the greatest directional opposition to the rectilinear frame. When diagonal tension is mixed with horizontal and vertical pull, it doesn't dominate; instead, it adds variety and structure to the composition.

Horizontal and vertical divisions can help to structure a painting by reinforcing the rectilinear frame. Vertical divisions are perceived more easily than horizontals: if you tip a horizontal landscape painting on its side, the painting's horizon will appear much stronger as a vertical, revealing the intensity with which we respond to verticals. This is a result of our upright orientation as human beings, mentioned earlier.

Divisions into halves and quarters, both horizontally and vertically, give a composition the stronger structural stability and unity. But, by themselves, such even divisions tend to be uninteresting. Odd divisions—into thirds or fifths—are more interesting. Many of the best compositional solutions, historically, have involved a combination of vertical and horizontal divisions into thirds, as well as diagonals. Further odd divisions, such as sevenths and ninths, are too complex to be discriminated and thus do not support a coherent composition.

The intersections of these internal divisions are often considered "aesthetic points"—that is, objects located at these points tend to gain both structure and interest. Of course, paintings should not be contrived to located objects at the aesthetic points. Good compositional solutions evolve out of the painting process rather than being dictated *a priori* by a set of rules.

The post-and-lintel concept from architecture is useful in understanding the dynamics of the rectangular picture frame. Think of the weight of the supported horizontal as pushing down, resisted in equilibrium by the verticals, and all three supported by the bottom horizontal.

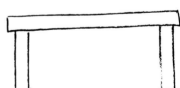

A vertical rectangle stands against the horizon and has a strength all its own. There is proportionately more weight pushing down on the topmost horizontal; on the other hand, the supporting verticals are stronger.

In a horizontal rectangle, the verticals need less strength to support the long upper horizontal. This kind of format therefore has a more passive kind of picture space.

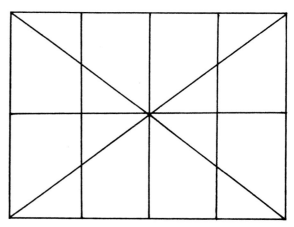

In addition to the diagonals, even divisions (both vertical and horizontal) form part of the substructure of the rectangle. Any development of the space of the rectangle that takes into account the diagonals and the even vertical and horizontal divisions will be stronger.

The rectangle is an immediately recognizable shape. Four points like these are connected by the mind's eye and seen as a rectangle.

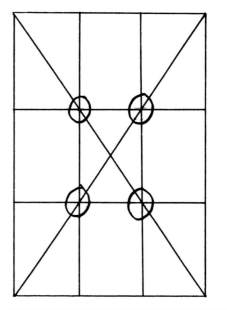

Diagonal connections are also part of our way of perceiving the four points of the rectangle, but they are not quite as obvious because they don't define the rectangle.

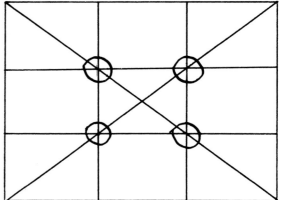

Dividing the rectangle into thirds both vertically and horizontally creates intersections called "aesthetic" points.

Horizontal divisions have to be simple in panoramas. As the horizontal-to-vertical ratio approaches 3:1 or 4:1, it is difficult to see any horizontal subdivisions. The vertical divisions, however, remain important as a way to give focus to the continuum of the panoramic space.

These two diagrams show two possibilities for dynamic divisions in a panorama, based on thirds or fifths. In the second example, the division into three-fifths and two-fifths approximates the golden section.

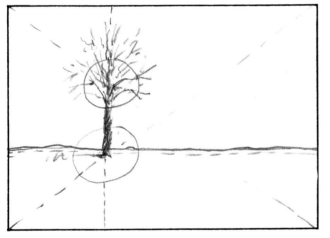

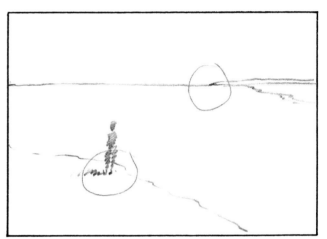

The vertical of a tree or building can be combined with a horizontal one-third of the way up from the base to strengthen the compositional structure. The circled areas indicate aesthetic points.

Using two of the aesthetic points along one of the diagonals can give strength to objects located at these points. In the example here, although both points are on the same two-dimensional line, one appears more distant, generating an exciting tension between two- and three-dimensional space.

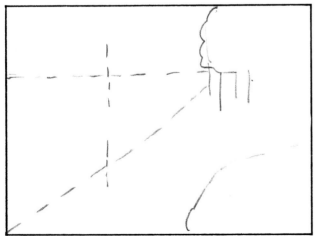

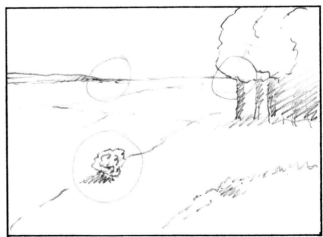

Placing the horizon a third of the way down from the top of the rectangle makes it function as what can be called a "structural" horizon for the painting. In this example, three aesthetic points come into play.

THE DYNAMICS
OF THE RECTANGLE

The rectangle of the picture plane has its own pre-existing dynamics even before the first mark is made on the painting surface. These dynamics form the context within which all other elements of the painting will be seen. In other words, the rectangular frame gives value to all the elements within it. It can help provide emphasis and contribute to a sense of order.

Whatever the kind of rectangle—vertical, horizontal, or square—the artist must be aware of what happens to individual shapes as they are placed in it, and what the effect of particular shapes is on the organization and energy of the rectangle itself. The examples on the next six pages demonstrate a variety of possible dynamics.

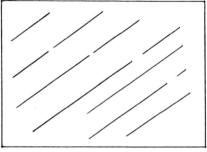

Diagonal lines are energetic as they work against both the horizontals and verticals in a rectangular format.

Verticals are more stable than diagonals but more dynamic than horizontals.

Horizontals are more passive.

Combining horizontals and verticals provides greater opportunity for structure because they function as extensions of the rectangular frame.

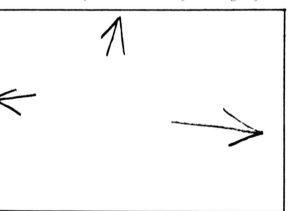

Angles and shapes that move toward and against the picture frame are disruptive and work against its structure, as well as against the containment of the image within it.

Placing shapes near the edge of the frame creates tension, disrupting unity. If the shapes are incorporated into the frame, the tension is reduced and the structure becomes more stable.

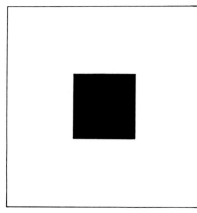

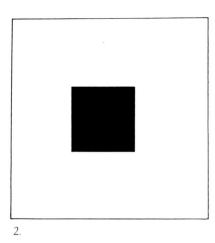

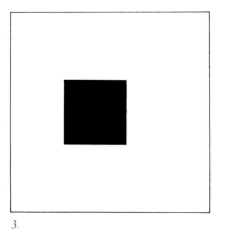

1. *Explore your reactions to these examples; then read my analysis on the facing page. My responses are included not to establish "right" or "wrong," but to encourage you to think about what you see.*

2.

3.

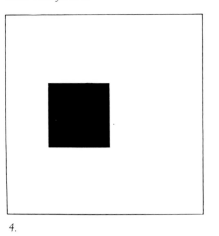

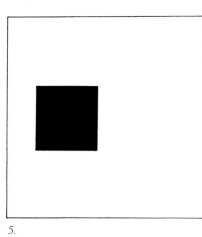

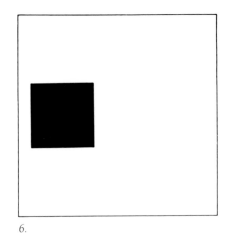

4.

5.

6.

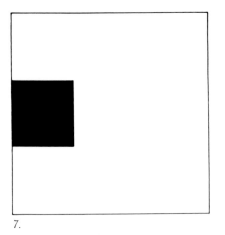

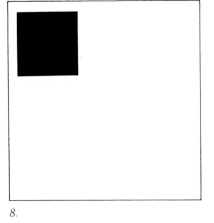

7.

8.

9.

1. *This internal square meets our expectations of being centrally located; it is evenly spaced from the edges.*

2. *Moving the square slightly to the left may be perceived as a mistake—a failure to place the square in the center. The strongest relationship is still to the center.*

3. *Here the spaces to the left and right of the square are clearly different, so there is no confusion with the central position. The square's closeness to the left edge increases the relationship to the corners.*

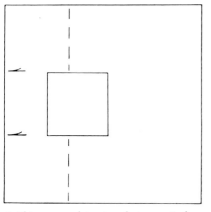

4. *This square relates strongly to a vertical division in thirds and to the left edge. The space between the square and the left edge is a strong shape in itself.*

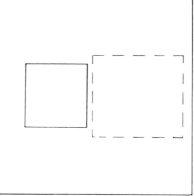

5. *The attraction to the edge becomes more structured. The negative space to the right becomes stronger, as if there were an invisible shape.*

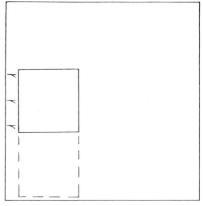

6. *As the square approaches the edge, the negative space underneath becomes better defined. The parallel lines of the square's left side and the vertical of the frame provide a tight structure.*

7. *When a shape joins with the frame, it becomes more static.*

8. *Here the structural relationship of the square to the vertical and horizontal of the frame provides strong resistance to the pull of gravity.*

9. *The square is being pulled down toward the corner, while the space between the square and the edge suggests movement away from the corner. There is some stability as a result of the location on the diagonal.*

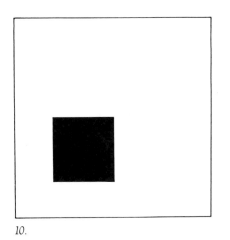

10.

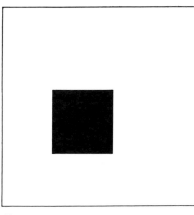

11.

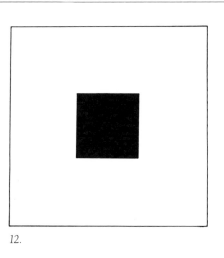

12.

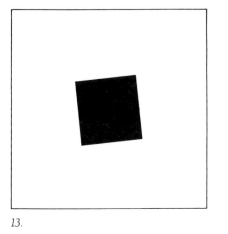

13.

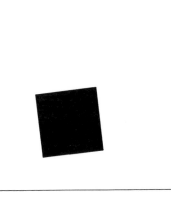

14.

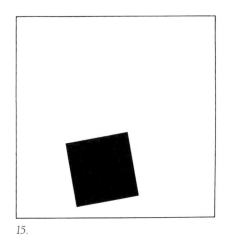

15.

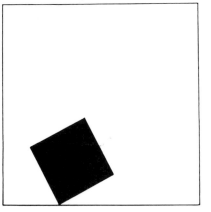

16.

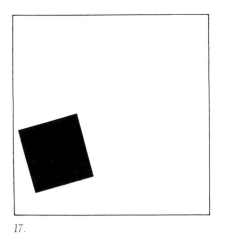

17.

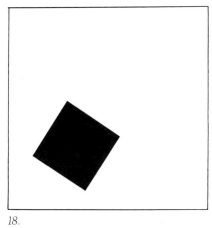

18.

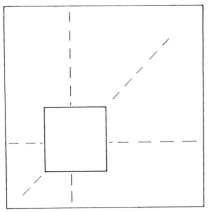

10. Compared to the last square on page 54, this one is more buoyant because of the space between it and the closest edge. Notice its relation to the division of the frame into thirds vertically and horizontally.

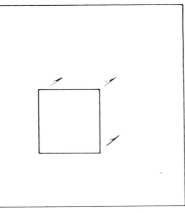

11. This square relates to the lower left corner, but it also relates to the center, so there is a slight diagonal movement to the right.

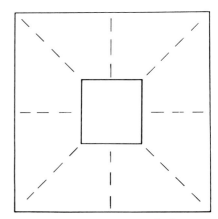

12. This centered square repeats the first illustration on page 54. It is included here to provide visual contrast for the other examples.

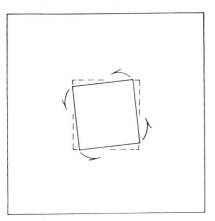

13. We expect the lines of the square to repeat the horizontals and verticals of the frame. Here the square takes on a counterclockwise movement because it is seen as pulling away from the stable, "upright" position.

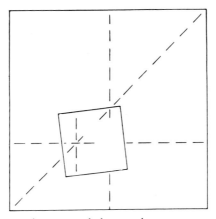

14. This square, which is tipped at a greater angle than the preceding one, hovers around an "aesthetic point." While it pulls away from the expected stability, it also relates to the center vertical and the horizontal third.

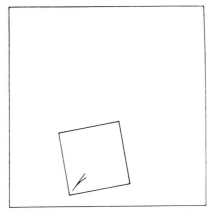

15. This square can be seen as lifting from the bottom toward the center.

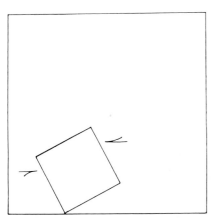

16. This square's placement is equivocal: it is active, yet its contact with the frame limits possible movement.

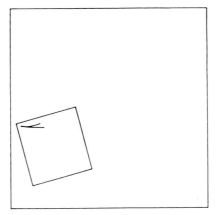

17. Near-contact with the left edge provides support for this square; the negative space has shape.

18. The placement of this square is ambiguous, without a clear relationship to the horizontals and verticals of the frame. It does, however, relate to the diagonal.

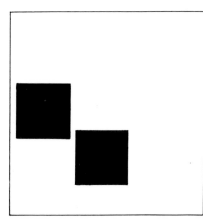

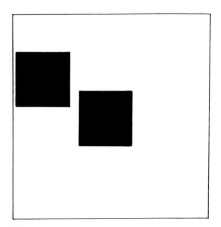

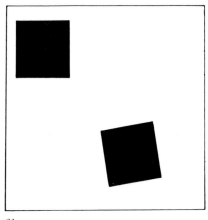

19. With two elements, as in these examples, one tends to relate more to the frame and becomes the "shape of unity," functioning as an extension of the rectangle.

20.

21.

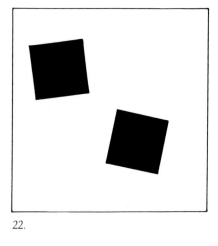

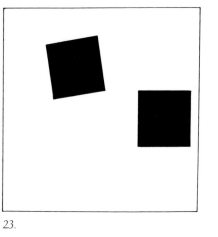

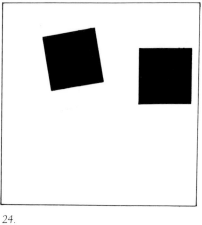

22.

23.

24.

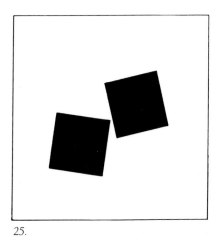

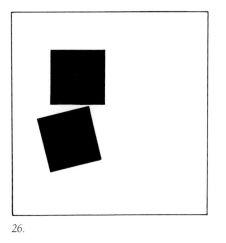

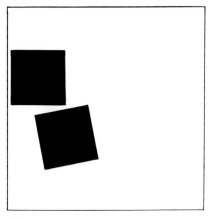

25.

26.

27.

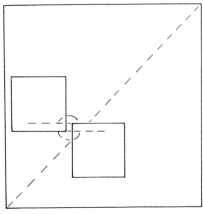

19. *The left square is anchored to the frame by its proximity to the left side and its placement at that side's midpoint. The right square produces more tension, as it is "cantilevered" from the side.*

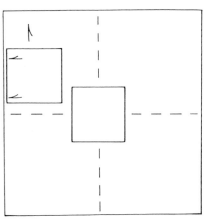

20. *Because it is dead-center, the right square may seem to correspond to the frame, while the left square moves up toward the center. But the left square may also seem stable because of its proximity to the edge, with the right square falling away from the upper left.*

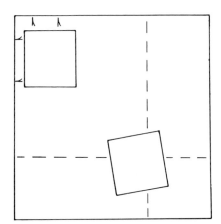

21. *The left square here clearly relates to the structure of the frame because of its location and position. The right square appears animated because of its contrasting position to the frame and the left square.*

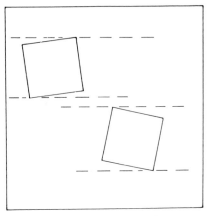

22. *The left square appears somewhat more stable than the right square because its angle corresponds more closely to the verticals and horizontals of the frame.*

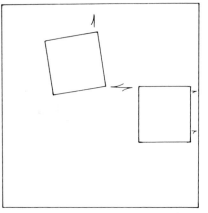

23. *The right square seems to pull the left square downward and right because of its stable relationship to the picture frame and its location slightly below center.*

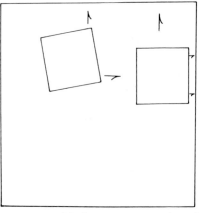

24. *Because of the large negative space beneath these squares, there is a sense of support and buoyancy absent in the preceding example.*

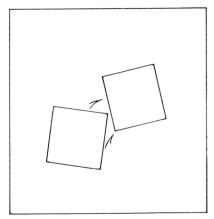

25. *These squares seem to be pulled toward one another near the center; this attraction almost unites them as a single shape.*

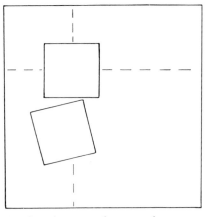

26. *These shapes are also attracted to one another, but because of the correspondence to the picture frame, the unstable bottom shape may appear to break, or fall, away.*

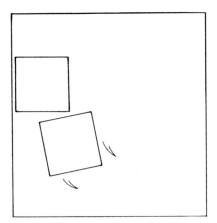

27. *Here, too, the top square is closely united to the frame while the bottom seems to drift away from, or be pushed away by, the top.*

In an effective composition, the painting's overall organization ties in with the visual frame to provide a supporting structure. At the same time this structure should have enough variety to make the composition interesting, with certain parts of the painting coming to our attention.

In general, the more strongly unified the structure is with the dynamics of the rectangle, the more dramatic any variations will be. A tight geometric structure that reinforces the rectangle, for example, can make a human figure very conspicuous: the organic stands out in this geometric context. Of course, such a contrast can become too conspicuous.

Structural unity should be felt, but it should not become the object of the viewer's attention. It simply provides a context in which to distinguish what is important in the painting. Often, when a painter seeks to emphasize part of an image, it is really the underlying structure, or the unity of the context, that needs reconsideration. It is this that allows the idea to be seen properly.

In sum, unity derives from the dynamics and structure of the rectangle, as discussed on the preceding pages. Specifically, the unity can be reinforced by echoing the structure of the rectangle in the development of the image. Variety is then added as parts of the image depart from the structural framework. Any variation in dominant patterns, shapes, and coloration can attract attention. A good composition involves a careful integration of the paradox implied by aiming for both unity and variety.

It is not easy to create a field that is totally unified. Normally the slightest variation in a field comes to our attention. In this example, the shape in the upper middle tends to separate from the field. None of the shapes is exactly the same, but this departs the most in character.

Each configuration here is unique. The only unifying force is the linear nature of the drawing. To emphasize one of the shapes, all the remaining shapes would have to be unified.

The regular shapes take on importance as irregular lines are added to integrate the remaining shapes into an overall field of unity.

Paintings tend to "read" from left to right, although the reason for this is not entirely clear—is it cultural or psychological? Whatever the reason, this human tendency is present in two-dimensional design, but often taken for granted. The picture plane is usually structured with a left-right flow by a skilled artist without conscious planning. The left side of the painting tends to be open and the right side tends to be closed, containing the movement of the viewer's eye.

Reversing an image provides the best indication of this dynamic. Some people think that showing a painting in a mirror reveals the exact opposite of the image, but this is not the case. Rather, the mirror image undermines the structure of the image, producing incoherence. A reversed image puts the barrier at the left, making the eye easily run off the right side. Obviously, trying to make an image work both head-on and in a mirror can compromise the original image.

Images within a rectangle are usually "read" from left to right. Proof of this tendency is shown here. The first diagonal is seen as ascending from the lower left to the upper right, while the second diagonal is seen as descending from the upper left to the lower right.

The rhythmic diagonals on the left are more energetic than the ones on the right because they move against the way we "read" the space.

TURNING FIELD (see pages 86–87)

The openness of the left border of Turning Field and the closed character of the right border become apparent when the image is reversed. There are different ways of closing the right border. One way is by using lines parallel to the vertical support on that side. Such a design, which reiterates the structure of the frame, provides an effect barrier. A strong illusion of space at this border, however, would not work effectively.

BALANCE, TENSION, AND VISUAL WEIGHT

Most of us look for some kind of symmetry within the stable rectangle of a painting, based on our sense of equilibrium, implied gravity, and such things as visual weight. Essentially, pictorial balance of any kind must respect the integrity of the rectangle. Different shapes can correspond with the rectangle, or they can push and pull against it, but the rectangle is still the basis for balancing an image.

A good composition appears balanced without being static or stiff. In this respect, it is not easy to get away with a symmetrical system of organization. Nowadays, it's much more common to use visual weights to achieve an asymmetrical balance. Many artists, however, feel that objects should not take on so much weight that balance becomes a major issue in the painting.

Because we attribute the pull of gravity to the picture plane, larger and darker objects tend to look heavier than smaller, lighter objects. In painting, however, balance and weight are much more complicated than in the everyday world. Visual weight is not simply the result of either size or relative darkness. Rather, it depends on the attention that the area or object commands.

There are many different ways in which an object acquires visual weight. A small object that offers great contrast to its surrounding can take on extra weight. Traditionally, artists have used a deep illusion of space on one side of the painting to offset a very large object (see, for example, my painting *Valley* on pages 70–71). Some objects command attention and acquire weight because of what they are—the most important example being the human figure. And sometimes objects known to be made of a heavy material in the real world may take on extra visual weight in a painting because of our knowledge of the depicted material.

Balance may be thought of as an equal distribution of weight, right and left, against the pull of gravity.

Visual weight is the result of some contrast in the picture. In each of the following examples, one shape takes on visual weight in contrast to the other shape.

1. *Larger size gives weight.*
2. *Greater mass gives weight.*
3. *Uniqueness takes on weight.*
4. *Darkness carries weight.*
5. *Greater structure gives weight.*
6. *Greater density gives weight.*
7. *A pattern with a strong appeal acquires weight.*
8. *Visual attractiveness lends weight.*
9. *Objects known to have weight may appear heavier than larger objects.*
10. *Objects with special interest take on weight.*
11. *Deep space carries weight.*

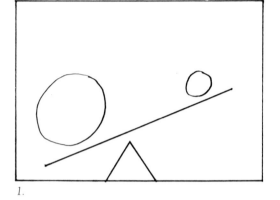

1.

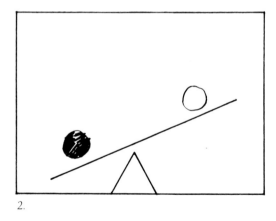

2.

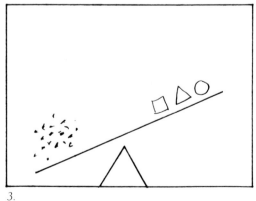

3.

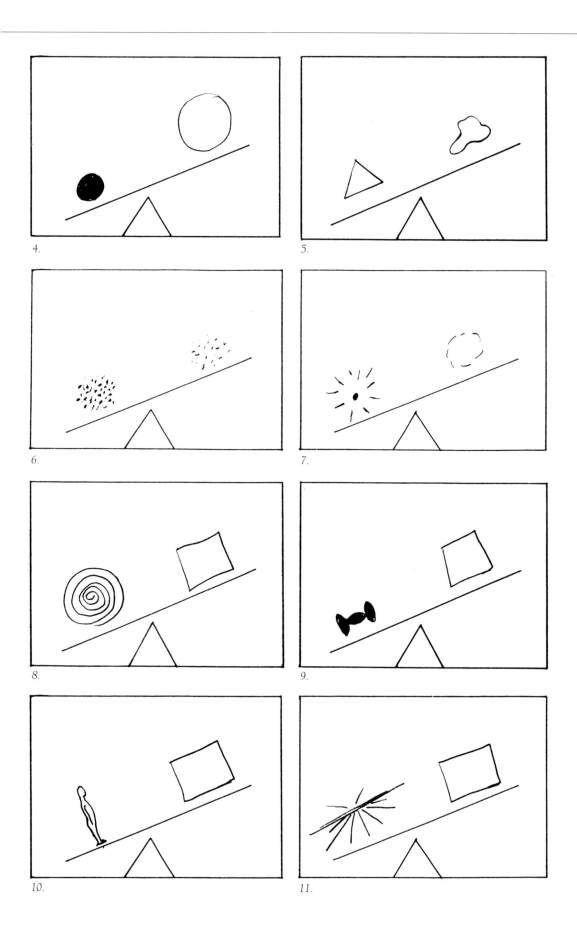

4.

5.

6.

7.

8.

9.

10.

11.

Placing a single weight off-center produces tension.

Movement away from the center and against the frame produces disequilibrium.

Placing a heavy weight against the bottom can threaten the integrity of the frame.

Shapes with edges that are not parallel to those of the frame imply movement against the frame.

A strong regression or progression can work against the two-dimensional picture plane and the frame, producing a sense of disequilibrium.

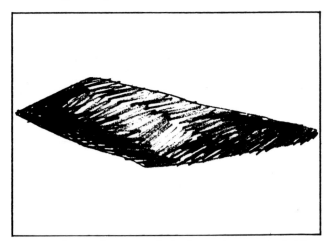

A massive shape pushing against the borders can be expressive, but it may also threaten the frame, as if about to break through, if its shape and direction are not subordinated to the frame's structure.

Perhaps the most important characteristic of landscape is scale—the suggestion of infinite space. A composition can be structured to give the impression of scale, as a metaphor for the scale of the natural environment. In other words, scale is not just the result of working on a large painting surface; it is a problem of composition. Small paintings can imply scale, while large paintings can lack scale. Indeed, one way to criticize scale is to project a transparency of a painting onto a screen without knowledge of the painting's actual size. A small painting with good organization and proportion can appear to be much larger than it actually is.

Fundamental to the effect of scale is a range of shapes, from large to small. It is the interrelatedness of these shapes, in appropriate proportion, that creates the illusion of size. There should be layers of subordinate shapes and patterns within the composition, all respecting the dynamics of the rectangle. If, for example, a composition is based on thirds, within the thirds there will be further subdivisions—all working together to structure the image.

Although the actual size of the surface is not the issue, putting scale into a small painting requires a lot of control. In very small panoramic paintings, it may be only the range of detail that gives the effect of scale, as the restricted working space and limits of the panorama format do not allow the structure of the picture plane to contribute very much to scale. A good example of this type of problem is my painting *Dirt Road* (page 82).

In this image there's little sense of scale because the sizes of the shapes don't vary too much.

Adding smaller shapes near larger shapes increases the sense of scale.

CHENEY
1983, screen print, 5″ × 20″
(13 × 51 cm), private collection,
courtesy of Orion Editions

The shapes in Cheney vary greatly in size, texture, and direction. Most important for the sense of scale, they are tightly interwoven, with the smaller shapes relating to the larger ones in both the illusion and the composition. Turning the image on its side reveals the tightness of the design through the middle, with the contrast of the large foreground and sky.

THE PROBLEM OF PANORAMIC SPACE

As indicated on page 52, the panoramic format presents a special challenge. When the vertical-to-horizontal relationship of the rectangle changes from 1:1.5 to 1:2 or 1:3, the horizontal divisions must be simplified. The reason is straightforward: there is less space to divide, and it is more difficult to see the space. At the same time, vertical divisions should be established, compartmentalizing the shapes and patterns. These divisions echo the frame and provide reference points, making the image easier to read.

The four paintings shown here are based on a 1:4.33 ratio (3 × 13 inches, 7.6 × 33 cm), vertical to horizontal. I wanted the image to be seen essentially as a horizontal band and found that, beyond a vertical-to-horizontal ratio of 1:3, it became almost impossible to make further horizontal discriminations.

NORTH OF ROCHFORD
1980, acrylic on paper, 3″ × 13″ (8 × 33 cm), private collection, courtesy of O.K. Harris Works of Art

In North of Rochford, *the later afternoon light casts long shadows, defining the horizontal plane. The strong value contrasts enhance the development of the grassy surface and amplify the sense of luminosity. Specifically, the luminosity of the grass is arrived at through many layers of greens, dabbed with fingers (see page 112).*

GOFORTH FARM—NORTH
1980, acrylic on paper, 3″ × 13″ (8 × 33 cm), private collection, courtesy of O.K. Harris Works of Art

In Goforth Farm, *the sense of distance and the scale result from the contrast between the farm and the stream. The horizon gives the sky just enough room, while allowing the greatest possible distance between the foreground and the background. The diagonal of the stream pulls away from the horizon, toward the bottom of the picture plane, producing some energy. The widest point in the stream is then set just beneath the buildings on the horizon, inviting a comparison. That the background buildings present a smaller shape than the foreground stream assists the scale and enhances the feeling of distance.*

In developing the images, I was influenced, strangely enough, by the scale and structure of certain nineteenth-century photographs. These photographs were uncompromising in their interpretation of the subject. With their sharp focus, they presented a broad range of shapes and gave a clear impression of scale. Too often, small paintings disregard critical edges and generalize shapes. In contrast, these photographs reminded me of what was possible.

In such an extreme format, the development of the horizontal plane requires the utmost subtlety because there is so little room for it. Nor is there much room for the sky, or for drama. The edges of shapes need to be clear, and contrast is a must, but only so much can be used without fragmenting the image. Only certain qualities in the image can be emphasized.

VIEW TOWARD WHITE HOUSE
1983, acrylic on paper, 3″ × 13″
(8 × 33 cm), private collection,
courtesy of O.K. Harris Works of Art

As in Goforth Farm, the horizon in View toward White House is structural, in the sense that the rest of the painting hangs from it and the eye doesn't wander into space. The large rock formations and the spaces in between are defined by dark on light and light on dark. Atmospheric perspective amplifies the negative volume in the canyon on the distant right. The wandering stream is used as a perspective device to help define the canyon floor. With its reflective properties, the stream provides a special opportunity for working light on dark and dark on light.

LOADING RAMP
1981, acrylic on paper, 3″ × 13″
(8 × 33 cm), private collection,
courtesy of O.K. Harris Works of Art

When Loading Ramp is turned to a vertical position, it is easy to see its horizontal organization into bands of green and gray. The clear edges of some fields, the sharply defined road, and the geometry of the architecture contrast with the soft, diversified patterns in the fields and trees. The architecture on the right provides unity and structure through its relation to the picture plane, and its relative flatness frames the deep space suggested by the green field behind.

STYLISTIC TENDENCIES

The danger in talking about the various aspects of composition separately is that the whole problem can get lost in a discussion of the parts. A successful painting must integrate all these aspects and more; it requires a natural evolution of the idea through the artist's hand. Given this flow in the handling of composition, a mature artist will show definite stylistic tendencies, resulting mostly from experience and temperament. Authentic style is not chosen by the painter; it is a reflection of the painter's orientation to the world.

An important aspect of style is the character of both the two-dimensional and the three-dimensional space in the image. A three-dimensional illusion that is analogous to the world as we see it may be somewhat neutral stylistically, while an image with spatial ambiguities and contradictions may evoke psychological tension. Similarly, the two-dimensional space can be arranged so that it is relatively neutral or produces tension. The results are neither good nor bad. But it is this manipulation of space that results in what we call "style."

Style can be talked about in different ways. One way is the traditional focus on the opposing styles of formalism and expressionism. Formalism emphasizes the structure and organization of the image more than its content. Expressionism, on the other hand, stresses the content, often using spatial tension to elicit an emotional response. The extremes are exemplified in the painting of Ingres (formal) and Delacroix (expressive), but these two tendencies are not mutually exclusive. Some painters fall more in between.

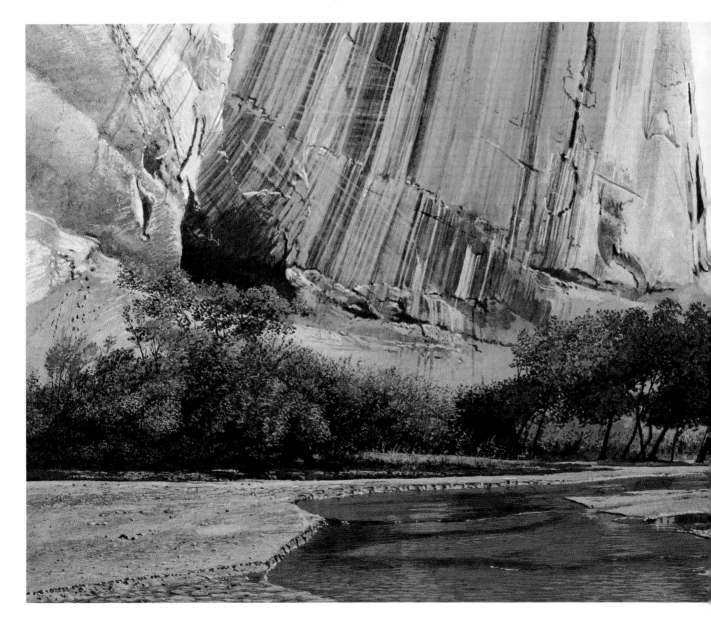

Style can also be considered for its documentary or technological tendencies, which can coexist with formal or expressive tendencies. The documentary tendency emphasizes the representation of the subject as it is (as in realist painting). The technological tendency stresses materials, methods, and devices—for example, airbrush techniques.

Beyond stylistic categories, one can refer to the general complexity and sophistication of the image's presentation. Traditional stylistic labels don't deal sufficiently with effectiveness within a particular style. In this regard I am most intrigued by what I call the "compositional metaphor"—the use of compositional dynamics to create a larger meaning, more fundamental to human experience than that represented by specific subject matter. Essentially, the composition becomes the force behind the image, as can be seen in the major paintings of Rogier van der Weyden, Raphael, Rembrandt, Degas, and others. I think that it is often this feature in the work of the masters that has led to consensus about their greatness.

Not even all the paintings by the masters reach the highest level of complexity, however. For a variety of reasons, paintings turn out differently. Some compositions may have shapes and movements that work against the rectangular framework toward some expressive end. Other important compositions may emphasize structure and control, but they fall short of the metaphorical. Still other, less complex—and often less interesting—compositions could be characterized as graphic, designed, or homogeneous arrangements.

WHITE HOUSE WALL
1982, acrylic on paper, 7″ × 16″ (18 × 41 cm), private collection, courtesy of O.K. Harris Works of Art, photo by Benjamin Fisher

In my landscape painting, the complexity of the surface—the brushstrokes, layering of the paint, and detail—serves as a metaphor for the complexity of the natural environment.

ORGANIZATION OF THE PICTURE PLANE

To show ways of integrating compositional strategies into the painting process, I have selected six paintings for compositional analysis. *Valley*—the first to be discussed—helped me rediscover my commitment to formalism. Its dimensions—larger than usual for me at the time—made greater demands on organizing the picture plane.

From my first glance at this subject, I knew that the buildings on the left and the distant vista on the right would be of primary importance in developing the painting. The imposing barn would help give structure to the picture plane,

but I would also have to make the illusion of deep space compatible with the picture plane.

The scene was based on a farm near Hubberton, Vermont. I was driving along a dirt road where there are some really good farm scenes, and I was attracted to this combination of barnyard and distant vista. I also liked the open quality, which occurs only in winter (in summer, foliage obscures the view).

I wanted to do a relatively large painting, and the extreme contrast between foreground and background provided the natural material for it. I was also intrigued by the

idea of using a heavy weight as a visual balance for deep space, and this subject gave me the opportunity to put this idea to work. The barn was very imposing, and the barnyard provided a frame for the vista. I was aware, however, that if I gave too much character to the buildings, the painting would become "about" the farm.

At the scene I took reference photographs from a vantage point that gave me the information I needed to develop the architecture parallel to the picture plane. The actual structuring of the composition, however, took place later, dur-

VALLEY
1982, acrylic on board, 16″ × 36″ (41 × 91 cm), private collection,
courtesy of O.K. Harris Works of Art, photo by Eric Shambroom

ing the painting process. When I was ready to paint, my first task was to determine the exact shape and size I wanted the painting to be.

The requirements for a painting are stiffer than the requirements for simply documenting a scene. I have spent a lot of time around farms, and I was interested in all the sights and scents. Although I knew that an accurate description of the architecture, earth, and vegetation would carry the scene for the most part, I also felt that some visual editing had to take place. People tend to mistake clarity in an image for close analogy to the real thing: if it is clear, they

think, that is what it must really look like. What happens is that the viewer fills in the gaps with his or her expectations. Because of this, I don't worry about authenticity too much—the viewer brings that to the work.

Effective composition contributes a sense of order to a subject—and less conspicuously, but with great impact, it also makes a place more believable. This painting was really meant to be about nature in the most general sense, and only secondarily about a farm. A strong composition was thus needed to provide some of the characteristic

dynamics of nature: structure, proportion, relationships between spaces and objects, and diversity.

Much of the structure evolved out of the painting process. Beyond simply liking the scene itself—and feeling that it held some unique potential for learning about deep space, structure, and especially scale—I knew that, as I worked, my involvement with the space of the picture plane would lead to the evolution of an acceptable composition. My interest in the specific place would soon disappear as the development of the space became more and more complex. Eventually I would get lost in and believe in the fictitious space of the painting.

I began by painting the sky. Atmospheric perspective dictated that the sky gradate from a soft blue to an off-white. I wanted the horizon of the ground plane to appear to be slightly in front of the distant sky, so my next step was to pencil in the shapes of the horizon and the buildings to get an overall idea of how I would use the space. Then I washed in the two major masses of trees, along with a few lines representing the edges of the fields. At this point the yard was treated only generally because I didn't have any ideas for it yet.

I wanted the volume of the building complex to appear convincing, but not be emphasized, only alluded to. If I were to place the buildings at an angle to the picture plane, this would emphasize their volume and compromise—to varying degrees— their contribution to the structure of the picture plane. Instead, to achieve additional spatial contrast between the foreground and background, I used lighting. The buildings are not only large but dark against the lighter and brighter landscape. The darkness of the buildings allows the foreground to function as a less conspicuous frame for the vista. The fact that the buildings break through the horizon also gives them prominence, and their monolithic shape,

DANIEL CHARD 82

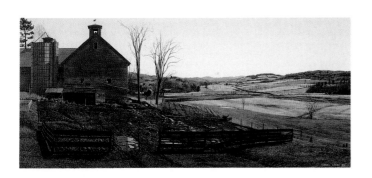

which forces the eye to consider them as one, lends them more weight. Thus, the weight of the buildings is a result not only of their size, but also of shape, value, and placement.

Given the emphatic geometry of the buildings on the left, I chose the hedgerows and stands of trees to structure the right side of the painting. I used the shapes of the linear hedgerows to create the illusion of three-dimensional space as well as atmospheric perspective. The grays in the trees unified them with the coloration of the buildings. The trees also provided an opportunity for containment on the right, and later in the painting process I tied them in with the end of the fence and the horizontal running through the middle of the painting. The fields were organized as a receding grid to give shape to the illusion of deep space.

I referred to my photographs at this point for information about the diversity of hedgerows and winter trees. These reference pictures also helped me deal with the surfaces of the buildings and—perhaps most important—with the mud. Initially I hadn't realized that the foreground would have to be totally fabricated. A foreground with just mud running off the bottom of the painting would not work. Instead, I put grass across the bottom, with a fence to strengthen the composition. The direction of the grass contributes to the overall progression of horizontal planes toward the horizon.

This diagram of Valley's *composition shows the unity of the image with the two-dimensional painting surface. The overall design provides contrast for the illusion of deep space.*

The diagonal organization of the painting provides both unity and energy for the image.

The lines here indicate the visual movement and suggest the three-dimensional illusion. The slight foreshortening in the building—visible in the finished painting only at the corners of the roof and the underside of the cupola—moves the eye in the direction of the lines in the fields.

The fence, water, and grass were totally fabricated in the painting process; there was no photographic reference. The fence and grass frame the bottom of the painting. The highlights on the water add interest to this area.

The grays in the trees provide unity of color, temperature, and value between the barn, fence, and forested areas.

The strong, graphic image of the barn is integrated with the two-dimensional picture plane. At the same time there is a subtle volumetric reference around the perimeter of the building. The illusion of clapboard was created with a ruling pen and acrylic paint.

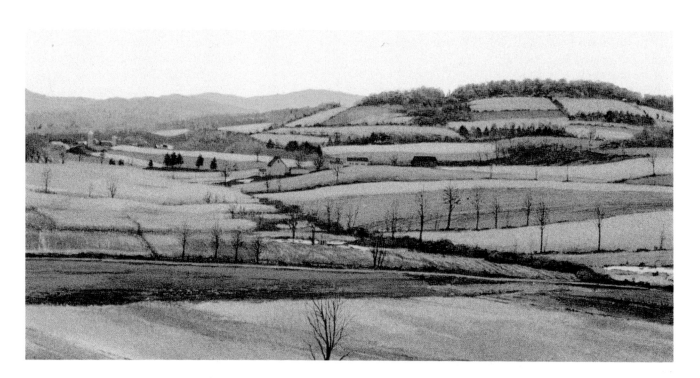

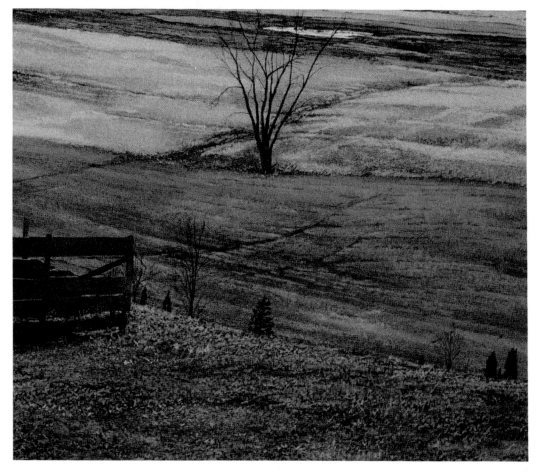

Atmospheric perspective and scale help to convey the illusion of distance. Notice also the definite edge between the ground and the sky, which helps to give a sense of atmosphere to the sky.

As the painting neared completion, this area seemed too flat and uninteresting. To "fix" this, I added texture to the grass, differentiating it from other areas. I also cropped the trees over the embankment to create the illusion of a hillside and "broke" a board in the fence.

DEEP LEFT/
FOREGROUND RIGHT

While developing *Pittsford*, I did not think specifically about compositional problems. I thought more about the illusion, atmospheric perspective, and the lighting. I also remember thinking about technical problems, such as how to get the weathered look of the siding on the foreground building and make it appear to be in shadow without showing what it looked like in the light.

The subject matter of *Pittsford* was very important to me. This painting turned out to be the beginning of a new direction for my work—what I generally describe as my backyard scenes, although my interest in the vista is still apparent.

When I am driving about, searching for ideas, I often look for the "boot hill" in a town because—as in this Vermont town—the cemetery frequently provides an overlook. This kind of slightly aerial view enables me to see a little more of the horizontal ground plane. I prefer, however, to use a vantage point that gives the spectator a believable position; thus, the foreground in my paintings usually comes right up to the spectator.

I spent a lot of time sitting on the edge of Pittsford's cemetery, looking and thinking about the potential of the view for a painting, and I photographed it from a few angles. I was especially intrigued by the white house and its simplicity. More than anything, I liked the honesty of this well-cared-for but unpretentious house. The garden, the shade trees, and the opportunity to articulate all the dark-and-light patterns between and around them also interested me. I wasn't sure about the grassy foreground, which didn't have much shape, but I thought its contour would contribute to the overall painting.

There seemed to be something almost spiritual about the white house. Although I didn't consciously focus on the contrast it provided, that became a feature in the painting, giving prominence to the house and also helping to shape the composition. In the finished painting, the white house is the largest shape seen in its entirety, giving it promi-

PITTSFORD
1983, acrylic on paper, 9½″ × 25″ (24 × 63 cm), private collection, courtesy of O.K. Harris Works of Art, photo by Benjamin Fisher

nence. (The carriage house on the right, so close to the edge, was not allowed such completeness).

Beyond the subject matter, this painting, like my others, is grounded in a structured illusion. The greatest distance is on the left, and the overall space of the scene runs between deep left and foreground right. I am not sure why I prefer this, but in the end it works for me—going between deep right and foreground left does not.

Given the deep left/foreground right layout, the spatial illusion is further structured by the understated horizontal plane, on which all the architecture is placed. This plane is strengthened by its relationship to the horizontal center of the painting.

It appears in the garden, the road, the shadows under the trees, and as the implied base of the houses. Contours move down to the horizontal plane from the left foreground and the background, supporting the continuity of the illusion.

The contour of the horizon itself cuts a clear edge across the top of the painting, expanding toward the top from the left side as the grassy foreground plane extends to the bottom. This provides a symmetry around the central horizontal axis of the painting (see the diagram on page 78). The buildings are then subordinated to the horizon and integrated into the landscape with foliage and cropping; no building is

seen in its entirety. The primary white house dominates because of its size, contrast, and the limited density of the tree.

The mountains and the foreground grass presented a challenge during the painting process. Both could easily have become monotonous. To avoid this, I varied the mountains' edges against the sky, the texture of their foliage, and their color through atmospheric perspective. I streaked the grass, which normally would have been green, with earthy browns and yellows to establish the contour and the left-right movement.

Demarcating the volumes on the ground was fairly easy, in that the shadows fell on the horizontal plane. It took a lot of time, however, to get the illusion of volume in the foliage. With the foliage, the lights and darks had to be controlled with overlapping to build up the volumes.

The midday lighting provided strong contrast. Eventually, as the contrast built up in the foliage and the white stood out against the darker foliage, this lighting became a force in the painting. Although it was a major concern for me, from the start, working on the subtle values and variations of green in the foliage helped me achieve more luminosity than I expected.

Looking back at this painting, I am interested in how the right side developed. The garden remained important, as well as the planes behind it, even though the carriage house was a more dominant monolithic shape and volume. This is because the building is cropped and the roof line is repeated in the background hedgerows. Even though the roof indicates a foreshortened volume, the building is, in terms of its effect on the painting, fairly flat. It is also a reference for lighting and scale in the rest of the painting; because the building is in shadow, it makes other things seem brighter and more intricate.

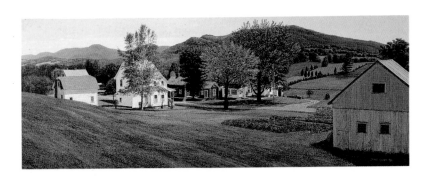

The composition of Pittsford opens from both sides, moving down through the center, around the structural axis.

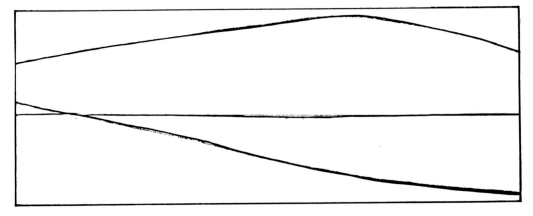

The left-right diagonal movement organizes both the two- and three-dimensional space. The result is complexity that energizes the space.

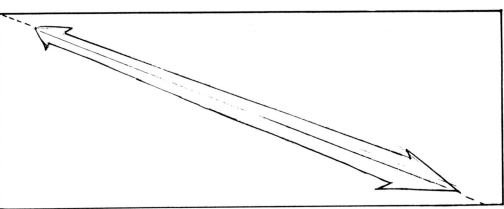

This sketch shows how the horizontal plane provides support for the three-dimensional illusion, specifically for objects such as buildings and trees. This plane moves between foreground right and deep left—a common approach for me. This directional movement is stronger because it goes against the usual left-right dynamic.

The patterns in the garden were created very spontaneously, using fluid paint and a watercolor brush. Varying the brush pressure also contributed to the variety of shapes.

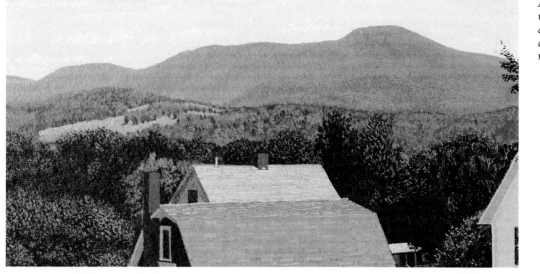

A blue-gray green was mixed with the colors of distant surfaces to varying degrees to develop atmospheric perspective.

Representing the burned grass provided an opportunity to define the contour of the hillside.

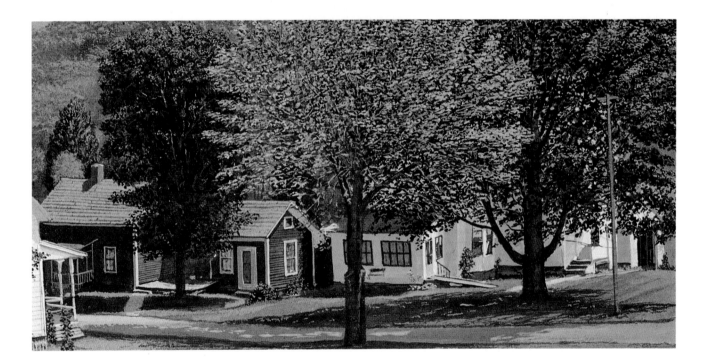

The combination of light on dark and dark on light here amplifies the illusion of intervals. Also notice how the angle of the buildings clarifies and structures the direction of the horizontal plane.

A successful illusion can be strengthened by considering the bases of the buildings and their location on the horizontal plane.

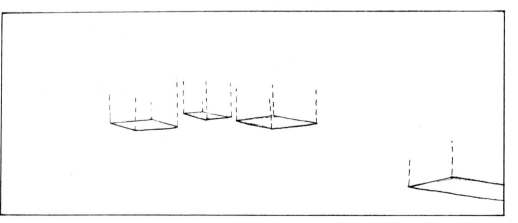

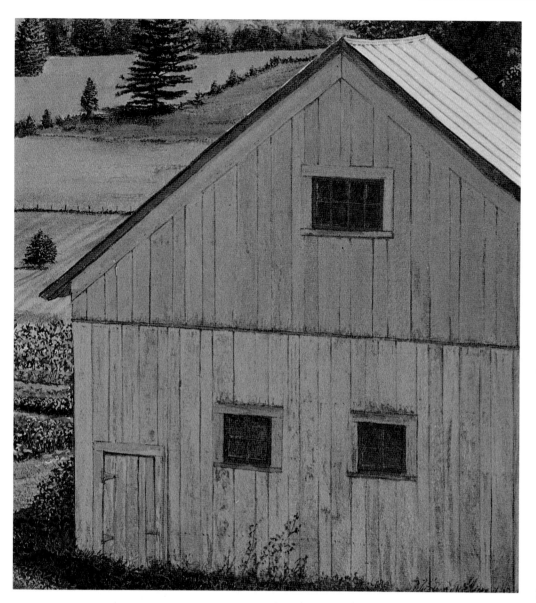

To suggest the weathered siding, I layered and smeared darker paint over off-whites, giving occasional attention to the edges of individual boards.

The large building on the right could easily have been disruptive, attracting too much attention because of its size. Moreover, the receding fields above it could easily carry the viewer's eye off the paper. To diminish the "largeness" of the building and integrate it into the two-dimensional picture plane, the presentation of its volume is limited. Its roof line repeats the lines of the fields, and a tree blocks the continuation of these lines out of the picture plane.

INTEGRATION OF
SKY AND GROUND

Dirt Road is a very special painting for me, as I accomplished what I set out to do. The tight composition, proportions, and range of sizes all contribute to its sense of scale. The integration of the two- and three-dimensional image is also very satisfying to me, reflecting what I think painting is about. This painting may not, however, be as attractive to other people, in part because the subject matter is more subordinated than in many of my other images.

The scene is based on a view in Lancaster County, Pennsylvania—one of the most beautiful places I have seen. The Amish farms there have their own look, and the austerity of the Amish lifestyle is quite apparent. Between the forested areas, there are large, open patches which, as a result of the farming, read as a grid moving back to infinity. This effect is amplified by the contours of the rolling, sometimes mountainous countryside.

The practice of strip farming—plowing and planting in alternating strips—dramatically defines the countryside. Seen foreshortened, the contoured fields take on unusual shapes. I was immediately struck by their graphic potential, as well as by the opportunity for defining the spatial illusion with shape. I felt that the horizontal ground plane could itself be the strength of the painting.

I photographed extensively for the series of paintings I did of this area. Sometimes, however, I was misled by the beautiful scenery. On occasion, the view was so handsome that getting a good painting out of it didn't seem a problem. I didn't think, for example, that Dirt Road would present such an important challenge. But I had no idea at the start that I would end up fabricating the foreground and have to integrate this foreground with the sky. Solving this problem became the strength of the painting.

In composing the painting, my first consideration was where to locate the horizon and how to subordinate the content to it. The sky meets the ground two-fifths of the way up from the bottom, providing a well-proportioned relationship. My photographs presented me with buildings below the horizon, and subordinating them in this way allowed me to de-emphasize the subject matter and instead stress the design.

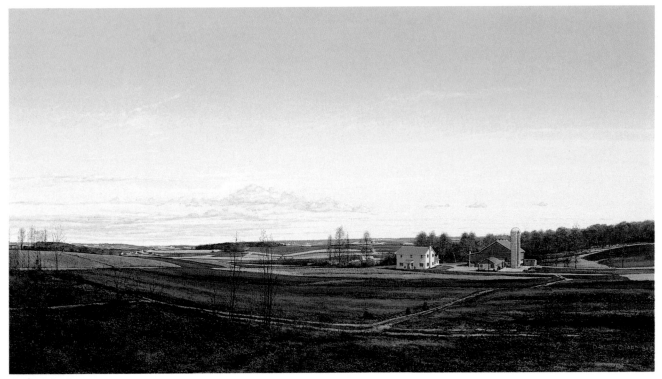

DIRT ROAD
1984, acrylic on board, 17″ × 35″ (43 × 89 cm), private collection,
courtesy of O.K. Harris Works of Art, photo by D. James Dee

As I blocked in the painting, the foreground became problematic. My reference photographs showed a freshly plowed field. Also, the left side, as it receded toward the horizon, had little sense of flow. To solve this I had to create a transition, from the foreground area nearly parallel to the picture plane to the sharp perspective on the left, going back toward the horizon.

The area around the horizon, from the left side through the middle of the painting to the farm on the right, had a strong potential for simplicity while defining extreme distance. Initially I exaggerated the light-dark contrast, to see how simply the horizontal plane could be defined in the deep space.

As the middle of the painting developed, I considered various approaches to the foreground and the horizontal plane. Painting the immediate foreground in dark grays and browns created contrast with the rest of the painting. But the question was how to shape this area. The road going back to the farm provided part of the structure for the horizontal plane. Its right angle—in perspective—to the farm buildings gave it structural strength. Geometrically, this right angle reinforced the horizontal plane, but keeping it from disrupting the picture plane and relating the foreground plane to the background were not easy.

I resolved most of the problems with the horizontal plane before developing the sky. My way of unifying the sky and ground—using a parallelogram, which combines the foreground angle of the road with the angle of the cloud configuration—was a conscious idea. This decision, however, had much more impact on the painting than I imagined. The parallelogram participates in both the two- and the three-dimensional space (see the diagrams on page 83). Its role is equivocal and, I think, dynamic. Structurally, the parallelogram is divided from corner to corner by the horizon, which becomes an axis for it and stabilizes the corners. The top and bottom points are balanced to the extent that each is located at about the same distance from the closest vertical of the picture frame. But, because of their structural tie to these verticals and to the horizon, the top and bottom oppose one another dramatically in the illusion of depth.

The rectilinear shape of the horizontal plane is also part of a parallelogram that unifies the picture plane around the horizon.

The same parallelogram—which can be seen as a rectangle in perspective—contributes to the structure of the three-dimensional illusion. It thus adds to the complexity of the composition by creating tension between the two- and three-dimensional.

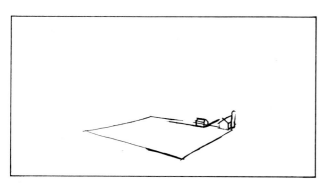

The foreground field is a rectangular plane seen in perspective. Because the house is square with it, the structure of the three-dimensional illusion is reinforced.

The numerous subdivisions are subordinated to one large rectilinear plane, which extends over the horizon. This structuring of the ground plane contributes to the organization of the picture plane.

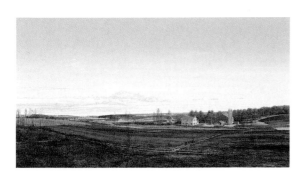

Looking at the painting vertically makes it easier to see the proportions of sky and ground. In general, viewing a painting in this way makes it easier to see the abstract structure, as there is less of a "pull" from the subject matter.

As diagrammed here, the lines and shapes flow across the picture plane at the horizon.

This diagram shows how the actual horizon hovers around a two-fifths division of the picture plane. The simplicity of the sky-ground relationship strengthens the painting, producing both stability and a sense of scale. The buildings are subordinated to the horizon.

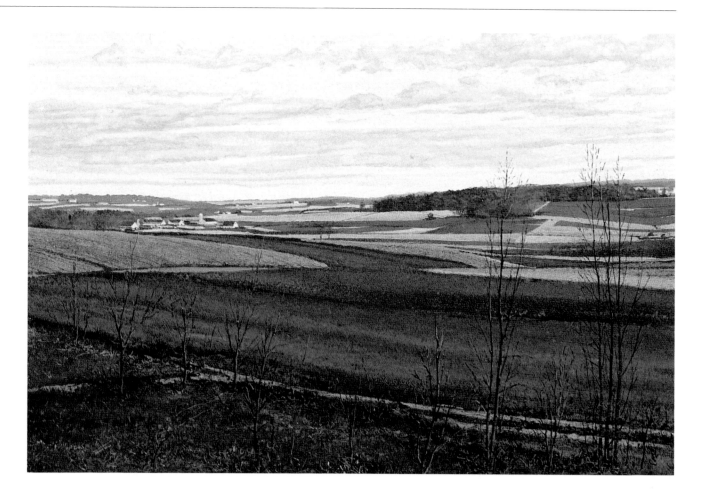

Although the distant vista makes use of some atmospheric perspective, it doesn't weaken the graphic quality of the overall image.

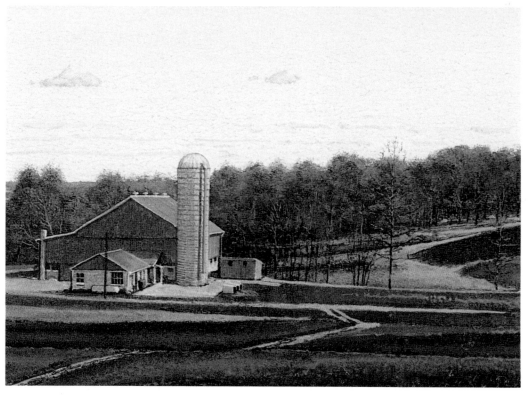

The buildings are integrated into the landscape, reducing their importance, but the organic trees behind provide a contrast, maintaining the buildings' clarity.

USE OF A FORCEFUL ILLUSION

One painting from my series on the Lancaster countryside had an unusual dynamic in the sweep of the field on the right. It was more than just different from the other paintings—the sweep, combined with the farm tucked into the hillside, intrigued me as well as other people. I had planned to use one of the paintings in this series as the basis for a screen print, and when I showed this image along with the others to my print publishers, Orion Editions, there was no question which would work best.

Why were so many people drawn to this image? As I tried to understand more about the image, I found that it is much more complex than I had realized. Although the bright farm, tucked between the foreground corn and the shaded hillside, is warm and dramatic, the energy of the print seems to result from the sweep of the field. But this sweep in fact occurs only in the far right quarter of the painting; up to that point, the image is generally parallel with the picture plane (see page 89). The energy of the sweep is mostly the result of its contrast with the dominant horizontal lines in the rest of the painting.

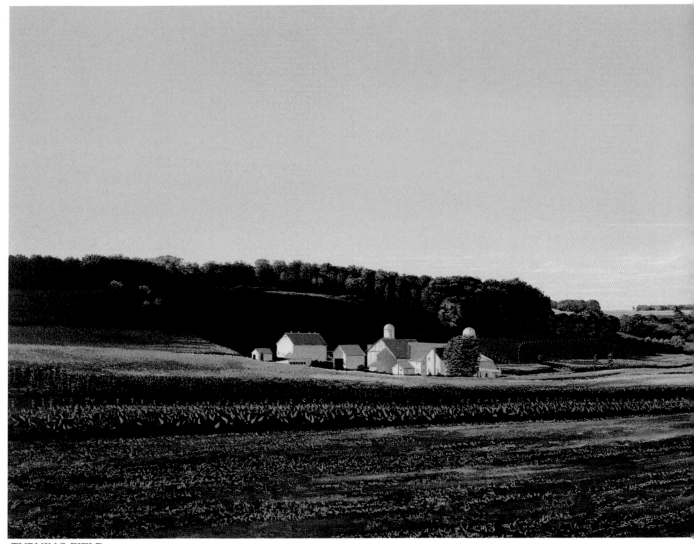

TURNING FIELD
1985, screen print, 13″ × 30″ (33 × 76 cm),
private collection, courtesy of Orion Editions

In general, the horizontal ground plane is defined without strong illusion, except for the foreshortening from the middle ground to the background. The dark green in the corn, nearly at eye level, highlight the strong angle. The dark green strip between the foreground and the corn also indicates the strong foreshortening, as well as the contour of the plane.

Yet, despite the strong foreshortening through the middle, the right and left borders flatten out. On the left, the darks and lights enter the picture almost as stripes; on the right, the sweep is de-emphasized near the border, so it does not compete with the picture plane. The green field across the bottom also flattens out at the edge, carrying the idea of grass without working

against the two-dimensional surface.

In contrast to the open fields and strong recession on the right, the illusion on the left is built in layers, going back through the farm to the top of the trees on the hillside. In this area the three-dimensional volume is convincingly conveyed by overlapping shapes, dark on light and light on dark. In particular, the darks suggest the volume between the back of the buildings and the hillside; they also imply the volume of the hillside itself.

The hillsides that go from the middle area to the right contain the illusion and allow it to interact more with the two-dimensional space. It was important to keep the sweep of field from going to the real horizon and to prevent the converging lines from ending at a vanishing point. If, for example, the white buildings near the end of the field had been placed near the real vanishing point, it would have been difficult for us to remove our eyes from them. As it is, our eyes travel through the sweep and continue moving toward the buildings or up to the hillside to the light green field, perhaps even going over the top, where the light green field meets the sky.

The tightness of the two-dimensional space amplifies the impact of the three-dimensional sweep of the field. The structural horizon cuts through the image about two-fifths of the way up from the base; another important horizontal, which is less conspicuous, is a quarter of the way up. The hillside shapes fold down into the horizon from the top. Also, the corn drops away from the structural horizon at the left like a taut hammock, joining it again at the white building. Overall, the energy of the picture is concentrated in a horizontal band through the middle of the image.

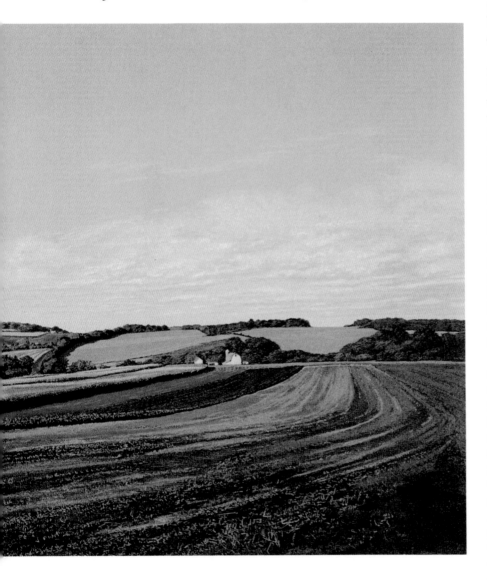

The field turns suddenly near the right edge.

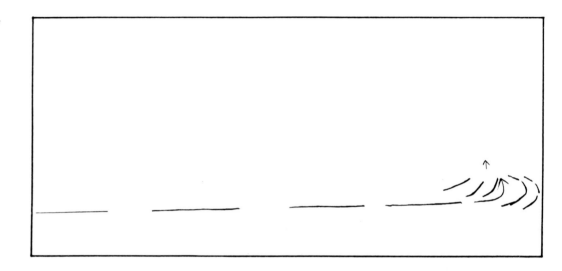

Seen in isolation, the sweep of the field does not have the strong visual appeal of other areas—although it is what the picture is all about.

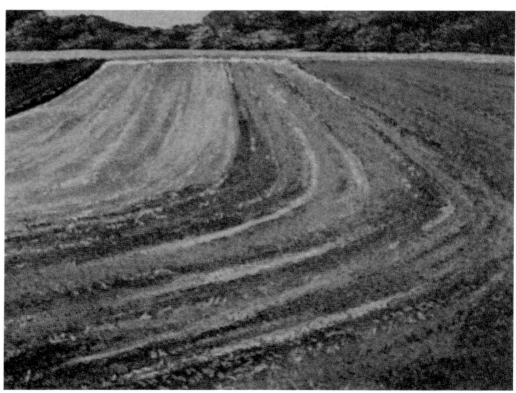

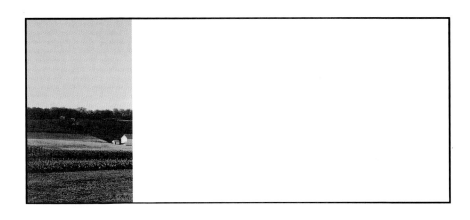

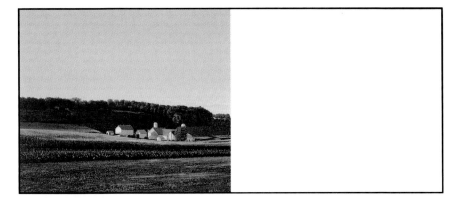

Although in Turning Field there is a strong illusion of depth on the far right, the left three-quarters of the image actually conforms to the picture plane, as shown here. The image also conforms to the picture plane at the outer margins, where the illusion of the grassy plain in the foreground loses its three-dimensional impact.

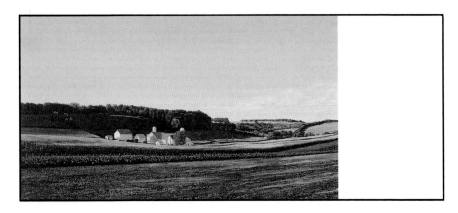

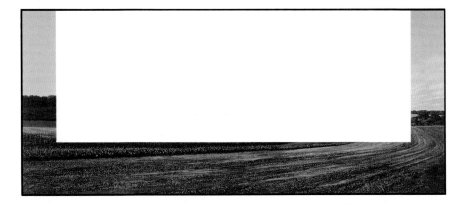

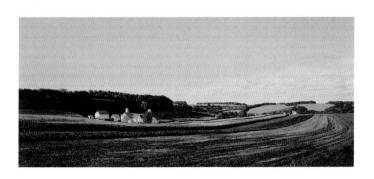

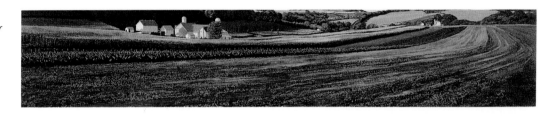

Cropping the image as shown here makes it easier to see the simplicity of the horizontal structure. The horizon is taut as it approaches the sides but slackens through the middle. This may be even easier to perceive if the picture is turned on its side.

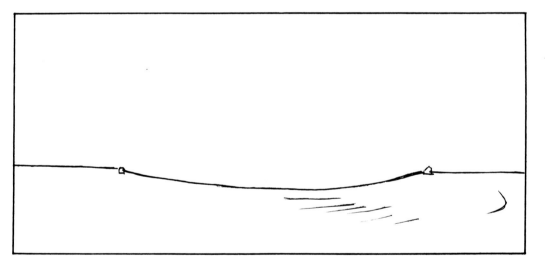

The lines and shapes in the picture flow from the outside and back down to the structural horizon.

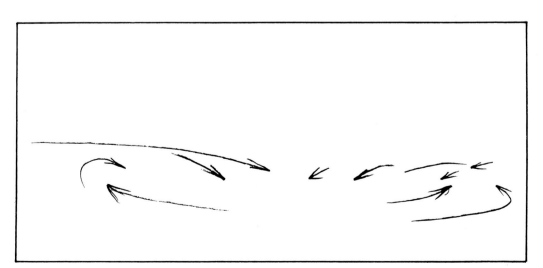

The hillsides present three zones of complexity. The definition on the left, behind the farm, is the most vague and general. On the far right there is somewhat more definition, while in the center there is the greatest variety and complexity.

The dark, shadowed hillside, with its inevitable ambiguity, provides the greatest contrast with the other elements in terms of light against dark, clear definition against unclear areas, and geometric against organic forms.

The hill behind the sweeping field halts the movement into deep space. It provides a background for the sweeping field without attracting too much attention to itself.

Although the central part of the image provides complexity, with detailing of the distant vista, it does not compete with the white buildings—focal areas on the right and left sides.

ELABORATION OF A
PAINTING IDEA

Near Rutland, Vermont, there is a mountain called "Bird's Eye." I have painted the back of Bird's Eye many times. The painting *Ira* was done before the one titled *Bird's Eye*, and many of the features developed in the first were continued into the second.

Among the strengths of *Ira*—strengths that made me want to do the image again—was the overall volume of the painting with the distant vista. The many contours of the horizontal plane, from the foreground to the distant vista, presented opportunities to develop the space the way I wanted. The shape of the mountains suggested the creation of a strong spatial relationship between the sky and ground. I was also intrigued by the possibility of dividing the painting vertically.

These interests can be seen in a comparison of the two paintings.

Both emphasize the strong contour of the mountain against the sky. Also, both paintings are generally divided vertically into two sections by the large area of trees. Structurally, they are built on the diagonal, with a strong structural horizon. The diagonal from upper left to bottom right is most apparent, but there is also a diagonal movement from bottom left to upper right.

Essentially, *Bird's Eye* is an elab-

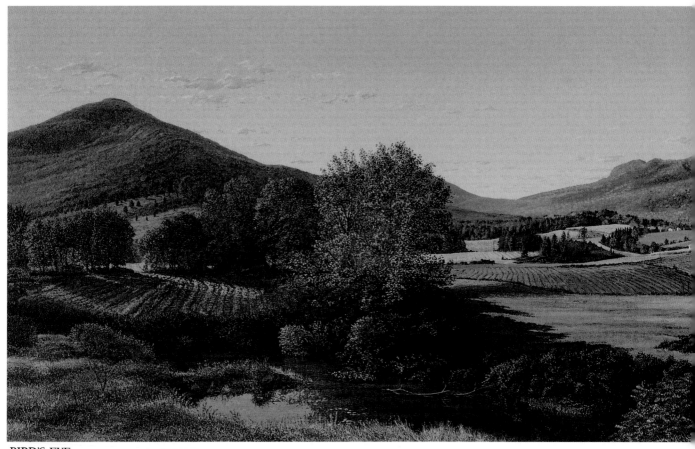

BIRD'S EYE
1986, acrylic on board, 13″ × 30″ (33 × 76 cm),
private collection, courtesy of O.K. Harris Works of Art

oration of a painting idea, with each area reconsidered to create stronger interest. The water in the foreground, for example, is more prominent in *Bird's Eye* than in *Ira*. In addition, the contour against the sky is disrupted by the foliage of the tallest tree, making the vertical division stronger. The surfaces of the fields in the distance are given distinctive coloring and contours in *Bird's Eye*, and there is further development on the right, including the addition of trees, which provides more contrast. A ravine zigzags from the foreground to the middle ground, giving more shape to the largest field.

Obviously, the main change in *Bird's Eye* is in the development of the horizontal plane. There are several organic lines dividing the horizontal plane and moving laterally across the picture plane. This lateral movement interacts with the many diagonal lines.

Finally, one should note the distribution of darks and lights in *Bird's Eye* and how they focus the image, as well as provide contrast for the atmospheric perspective. The contrast is important where the light breaks through the trees on the left and where the distant dark trees on the right contrast against the light fields.

IRA
1984, acrylic on board, 13″ × 30″ (33 × 76 cm), private collection, courtesy of O.K. Harris Works of Art

The dynamics of Bird's Eye *are strongly affected when it is reversed. Some of the compositional elements—particularly the dominant diagonal—are more easily seen. Just as viewing a painting on its side can help one get past the subject matter to see the underlying dynamics, so, too, can a reversal—at least if one has already spent some time studying the unreversed image.*

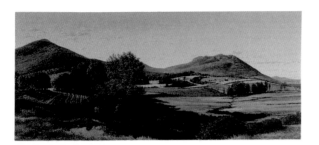

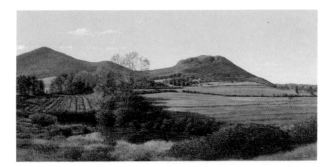

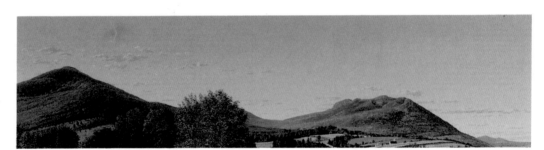

The sky in Bird's Eye exists as an independent shape. Its edge relates to other lines and movements across the picture plane. The clarity of the edge also sharpens the distinction between atmospheric sky and physical ground.

This high-contrast black-and-white photograph shows how the darks and lights have been juxtaposed to create the greatest contrast. The lights are often framed by darks. The strongest darks provide a structural band through the center.

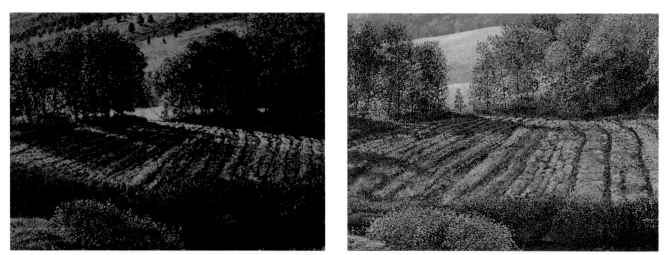

In Bird's Eye (left) the backlighting and cast shadows on the plowed fields provide greater contrast than in Ira (right).

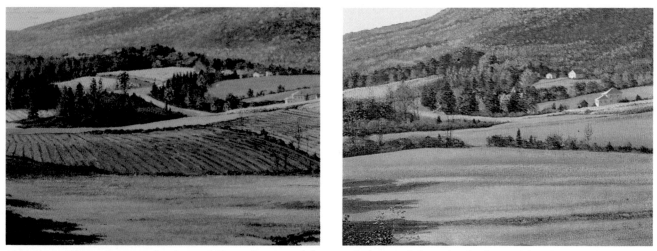

The contoured field in the center of Bird's Eye (left) provides greater definition to the horizontal plane. Also, the illusion of three-dimensional space is exaggerated by the stronger light-dark contrast in Bird's Eye.

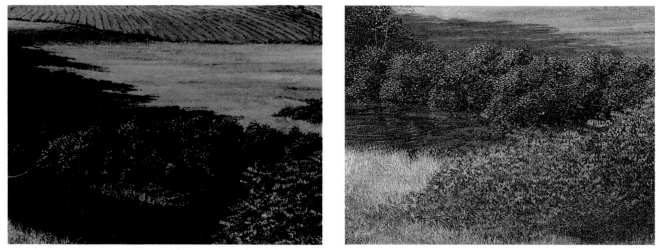

In Bird's Eye (left) the water bleeds off the bottom of the painting, providing an entrance into the scene—unlike the wall of foliage in Ira.

My painting *Brick House* represents a movement away from the panorama. It is warmer than many of my recent landscapes, and I think it suggests an increasing interest in people, even though people have yet to appear in my paintings.

In my panoramic landscapes, a large part of the personal feeling is created by the miniature format; the format draws in the spectator, who has to get close in order to take in the details. Doing paintings that "read" more easily from a distance demands more from the subject matter, since the spectator is not automatically drawn into the painting. In *Brick House* the personal element occurs in the backyard, which reflects so much about the people who live there and their everyday environment. I suspect that showing their faces would distract from our perception of their environment. At any rate, this seems a comfortable environment, inviting to anyone.

The "portrait" aspect of this painting comes out in the care the inhabitants have given to the yard, which reveals both something of their value system and their modest

BRICK HOUSE
1985, acrylic on paper, 12″ × 19″ (30 × 48 cm),
private collection, courtesy of O.K. Harris Works of Art

means. Having spent most of my life in rural areas, I see in such scenes a kind of independence as well as authenticity. This scene might appear a little too pretty, but the flowers and shrubs are not manicured; they are just there, scattered about without a great plan. The house has no decorative trim. The white woodwork is simply functional framing for the doors, windows, and roof. The painting offers a slice of life beyond the knowledge of far too many urban and suburban people nowadays.

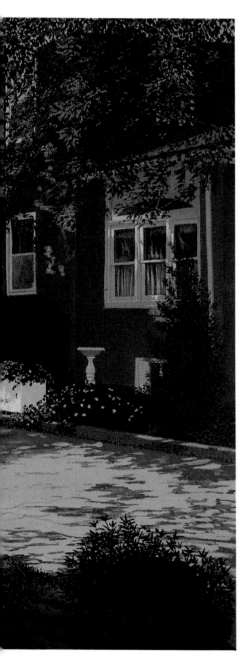

To understand the visual effect of this painting, one might compare it to *Alloway* (see page 126), which also depicts a backyard scene. In *Brick House* the visual attractiveness has a lot to do with the contrasting lights and darks, which create focus and emphasis. Blocking out the sky also lends emphasis to certain parts. And within the buildings and foliage, darks and lights are dramatized to provide clear definition of the negative volumes, or intervals.

Beyond this immediate visual drama is the painting's organization. In developing this painting, it was clear to me early on that the chairs, trash can, and clothesline in the center were going to be important. The contrasting bright white of the garage also attracted attention to this area. Although I wanted to include the truck, I didn't want to fill up the center volume. Moreover, the truck, with its mechanical presence, could easily have become a focal point. In the finished work, the truck *is* located at a key point in the composition (at the convergence of the major diagonals), but its importance is subdued by the overlapping foliage, the forceful verticals of the trees (which break up the diagonals), and the stronger white of the towel on the clothesline.

Essentially, the composition is set up to frame the central third of the painting (see the diagram on page 101). To further offset this central rectangle, there is a lack of definite edges elsewhere. Although such an outright central emphasis might be boring, I suspect that a person could look at this painting for some time before noticing it.

The picture plane is also structured by the strong horizontal through the center, which divides the space in the simplest way. The overall horizontal structuring is clearly revealed when the painting is turned vertically, on its side. It helps that the central horizontal line serves as a kind of horizon.

The pull of the diagonal curb and road toward the truck adds interest by moving against the eye's natural tendency to read the painting from left to right. At the same time this diagonal is countered by a diagonal running from the top down through the trees, so that it doesn't disrupt the painting and become an expressive element. Moreover, the large tree "stops" the diagonal and reinforces the frame by forming a strong vertical division, one-third of the way in from the left. A less conspicuous vertical appears a third of the way in from the right.

The illusion of depth is set off by the diagonal movement and further structured by the right-angle positioning of the house and the driveway. The shadows in the grass in the left foreground, as well as the shadows in the driveway, clarify the horizontal plane. They also slow the movement back in space. The most distant trees and bushes then limit the depth of the space.

The band of yellow-green serves as a kind or horizon, although the vanishing point for the house suggests where the real horizon would be, if it could be seen. In painting this scene, I moved the real vanishing point to the left in order to reduce the pull toward the horizon. I wanted the horizontal line in the garage to be reasonably close to the strong horizontal of the backyard—pulling the spectator into the backyard, but also creating tension with the space beyond it. The longest continuous lines going toward the horizon are not allowed to extend to the point where they would converge. Instead, the movement to the yard and its implied interval is done as much with overlapping as with converging lines and diminishing scale. In particular, the dark trees and shrubs overlapping the luminous yard strengthen the illusion of the backyard's volume.

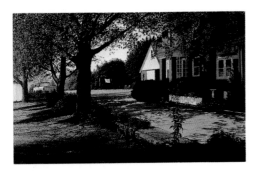

Brick House *is structured around a horizontal through the center of the painting.*

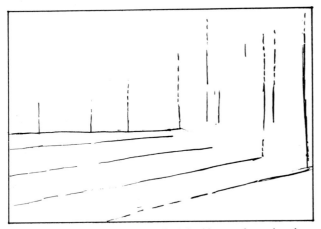

The volume of the painting is generally defined by two planes: the sides of the buildings and the ground moving up to the buildings.

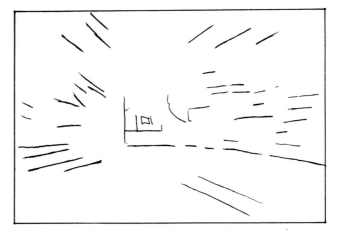

The top diagram shows just the vanishing point and perspective lines. As can be seen, the attention given to the center of the painting is not really based on perspective. The strongest lines indicating perspective—the curbs—are interrupted before they approach the vanishing point. Instead, the contrasting rectangle in the center becomes a focal point, with lines seeming to radiate from this area.

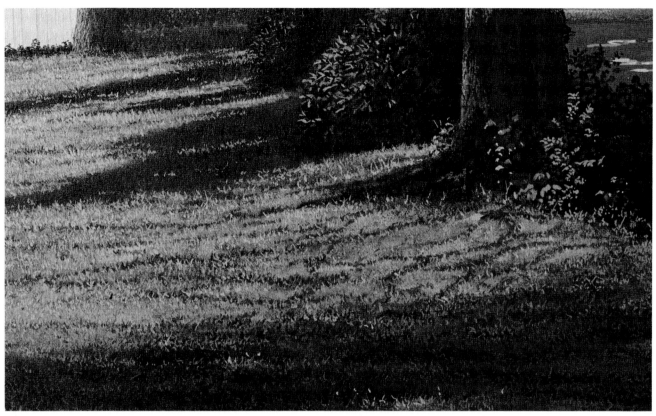

The shadow patterns in the grass are shown in perspective, becoming smaller as they move back toward the truck.

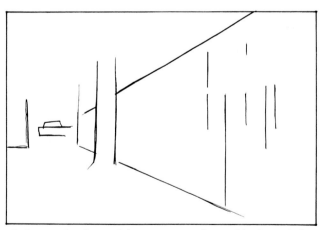

The horizontal and vertical divisions are complemented by diagonals that move from the top and bottom right toward the truck. The verticals prevent the truck from becoming a focal point.

Cropping the truck and limiting its contrast with the background also keep it from becoming a focal point in the painting.

Like many of my paintings, this scene has a deep left/foreground right movement; reversing the image reveals this dynamic more clearly.

This black-and-white photocopy shows the even distribution of darks and lights, which helps to unify the painting. The overlapping darks and lights amplify the illusion of three-dimensional space.

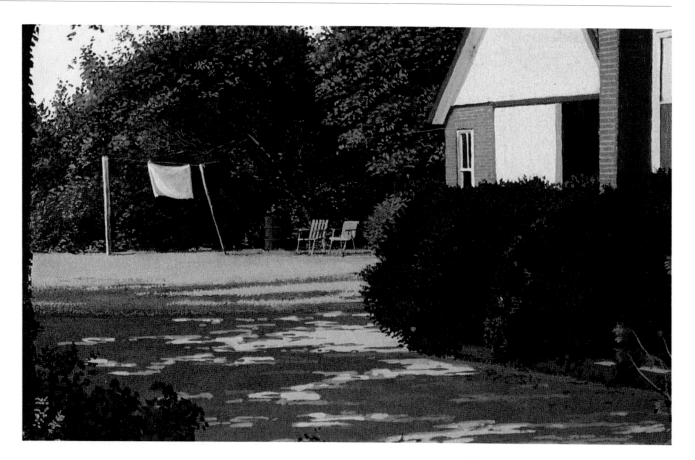

This sketch diagrams the image within the image shown in the detail above. Notice that the outer portion of the painting frames the inner third. Its strong structure repeats the shape of the rectangle.

A CHECKLIST FOR CRITICIZING PAINTINGS

When we look at a painting, we bring strong expectations to the process of criticism, based on what we already know about painting. These expectations condition, to varying degrees, what we are able to see. Effective criticism requires a kind of openness to experience, but it isn't enough simply to be open. We must also be aware of all the different influences on our perceptions. Intellect, general perceptual and conceptual experience, and cultural predisposition can all affect our receptivity to certain stylistic tendencies.

Once of the biggest problems in learning to criticize paintings effectively is caused by confusing personal likes and dislikes with analysis. This interferes with attempts to be more objective about what one sees. It is possible to like a painting that is not particularly good, just as it is possible to dislike a good painting. Liking or disliking reflects something about one's personality but doesn't necessarily reveal anything about the painting.

Obviously, there is a special problem in criticizing one's own work; not only is there a psychological investment in it, but also one's vision adapts to the work's idiosyncrasies. The longer one looks at something that is incorrect, the greater the tendency to see it as correct. Taking a fresh look at a painting—upside down or on its side, in a mirror, in a black-and-white photograph, out of focus, or with sections cropped off it—can help to reveal its design and representational characteristics more clearly. Putting a painting aside for a while is another way of seeing it more clearly.

This checklist covers a range of potential visual properties to look for when critiquing landscape paintings. Sometimes people focus so narrowly on their own specific interests that they overlook other features that may be important to the way the painting works. Used as a reminder, this checklist can help prevent this problem and also increase one's objectivity. Keep in mind that paintings differ primarily because of their spatial characteristics, so asking questions about this aspect will provide the most useful information. Don't, however, try to force the same criteria onto every painting.

1. Is the representation of the space and the objects in that space symbolic or analogous? Has the spatial analogy been deliberately distorted? What kind of perspective, if any, has been used—linear or atmospheric?

2. Characterize the volume of the painting—is it deep or shallow?

3. Consider the horizontal plane—how is it defined? Determine whether it serves as a foundation for architecture, stands of trees, or other objects in the landscape.

4. Identify the horizon's height and the tilt of the horizontal plane. Where is the viewer's vantage point?

5. Characterize the weight of the horizontal plane. Does the definition of the plane provide the illusion of mass, or is its weight the result of dark colors, large objects, or other features?

6. Describe the subordinate horizontal planes. Identify their hierarchy, from the most to the least important. Consider any foreshortening. How tightly structured are these planes, and what are their dynamics, both internally and in relation to one another? Do they form an open or a closed structure?

7. Consider the contours of the horizontal plane. Have they been established through pattern or shape? What is the hierarchy from major to minor? Study their interconnectedness—are the contours distinct, or do they flow into one another? Do they overlap, and, if so, does the overlapping amplify the three-dimensional illusion?

8. Observe the shape of the horizon.

9. Look at the surfaces, and try to understand how they function as a support for the illusion and a foundation for the volumes. Consider them as a grid defining the horizontal plane, and look for movement in the plane—forward, backward, left, and right.

10. Identify the different types of patterns on the surfaces—fine or coarse, dense or open, homoge-

neous or heterogeneous. How do they contribute to the illusion?

11. Observe the edges of the surfaces. How do they contribute to the definition of planes? To the illusion?

12. Are the volumes of objects presented from their most advantageous view (in terms of descriptive information)? How do the volumes relate to the horizontal plane? Is there a structural relationship?

13. Look for negative volumes as well as positive volumes. What is their relationship in establishing the illusion?

14. How clear are the intervals between volumes in the three-dimensional illusion? How are these intervals established? Does the articulation of the horizontal plane help define them?

15. Where is the light source? Is the lighting consistent throughout the painting? How are lights and darks used in defining the overall illusion as well as specific spatial intervals? Are cast shadows used to establish volumes and define the horizontal plane?

16. Consider how the shapes contribute to the representation. Are individual shapes specific or generalized? Identify the vantage point from which the shapes are viewed and their location in illusionistic space. How is each shape characterized by the articulation of its edges and implied volume?

17. Analyze the pattern(s) internal to each shape. Note differences in size, direction, character, density, contrast, transition, homogeneity, and color.

18. Are any shapes cropped at the picture's edge? Does this cropping make what is seen more or less convincing?

19. Is color in the imagery visually analogous to nature or symbolic?

20. How is the two-dimensional space of the picture structured and maintained? How does it correspond to the rectangular structure of the frame?

21. Look for lines, edges, and movements that divide the picture plane. Specifically, identify diagonals, verticals, and horizontals, and their relationship to the frame.

22. Notice any even or odd divisions of space. What about focal points? Are the aesthetic points utilized?

23. How has balance been achieved? How have different shapes and areas been given weight?

24. Examine a reverse image of the painting, if necessary, to identify the left-right organization.

25. Is the composition open or closed? Does it bleed off the frame, or is it contained within it?

26. Isolate the positive and negative space to consider the image's overall graphic quality.

27. Characterize the design in terms of its simplicity or complexity. Is it more unified or more varied? Also consider these qualities: contrasting or homogeneous; massive or delicate; linear or tonal; organic or geometric; angular or blended.

28. How does the location of shapes relate to the rectangular framework? Do the shapes create tension with the frame by moving against it?

29. How are the transitions between lines, movements, or shapes handled? Are they abrupt, or do they blend in?

30. Consider the compatibility of two- and three-dimensional space. Does the two-dimensional picture plane or the three-dimensional illusion dominate? Or is there an equilibrium between them?

31. Consider the proportions of the shapes within the rectangle, from the largest to the smallest. Is there contrast in size? Do the shapes relate proportionally to one another?

32. Is there color contrast, as in a complementary relationship? Or is the painting more monochromatic?

33. What is the stylistic emphasis of the painting? Are there exaggerations or distortions of the real world, which contribute to an expressive end? Is the emphasis on structure and organization? Or is the emphasis on an accurate description of the subject? How important is the medium or a specific technique?

THE PAINTING PROCESS

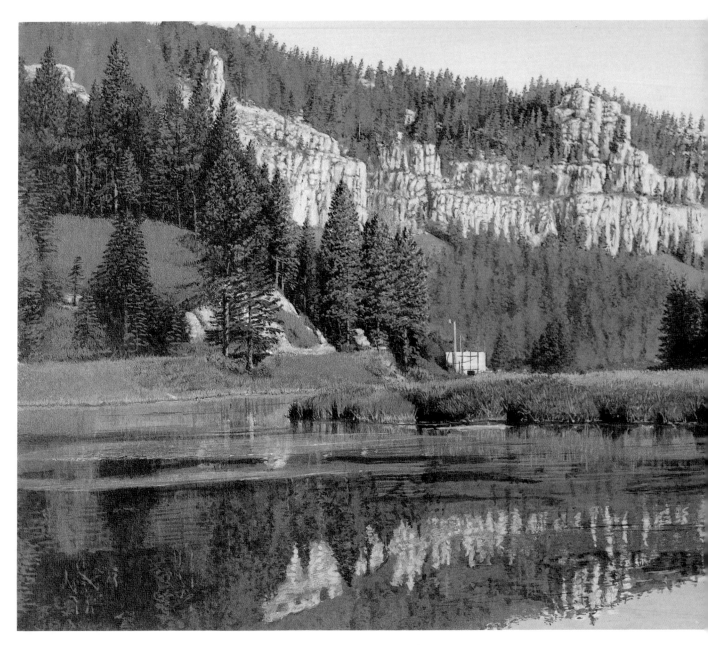

The acrylic medium provides a unique opportunity for the painter to discover his or her creative resources. With good drawing skills, a familiarity with the mechanics of working with the medium, and a focused painting problem, it is possible to achieve a spontaneity not often experienced with other painting media. It takes hard work, but eventually one can learn to use acrylics almost automatically—without being distracted by trying to figure out how to mix a certain color or paint weathered wood, for example. When this level of facility is reached, efforts can be directed toward the painting idea—composition, the organization of space, and the overall structural unity.

Because working with acrylics has played such an important part in the development of my own painting style, and because it has opened doors for my students, I have decided to conclude with a closeup look at how I use this medium. I have tried, however, to design this section so that much of it can be applied to any medium. I don't, by the way, see myself as a technical expert on acrylics. My intent is more to show the advantages of this medium for my way of painting and to indicate the potential play it allows.

Keep in mind that this section represents the discoveries of just one painter. Any real change in a person's performance as a painter must begin with his or her particular skills and knowledge. The answer is not to adopt another artist's style; instead, the evolution of a personal technique comes out of a reconsideration of the painting process as a whole.

SPEARFISH CANYON
1981, acrylic on paper, 7″ × 16″ (18 × 41 cm), private collection, courtesy of O.K. Harris Works of Art, photo by Benjamin Fisher

EQUIPMENT AND WORKING CONDITIONS

There are idiosyncratic aspects to the way I paint, but I prefer them because I have found that even the simplest and most pedestrian aspects of the painting process can present major obstacles to a free and natural approach. This is especially true for the painter who paints for many hours a day. And it is not just a matter of physical comfort; it can also have an effect on the paintings. My equipment and working conditions allow me to be very productive and to get the most out of my skills.

PAINTS

The paints should be organized on the palette around a small container of water for mixing, so that there is little hand movement between the paint and the water. The colors selected and their arrangement on the palette are matters of personal choice. Someone who has difficulty with color mixing may want to be systematic about it; organizing hues according to the color wheel may be an advantage in this case.

Whatever the arrangement, it's best to use the same system regularly so that you never have to look for a color. My painting method requires rapid color mixing; having to search for a color would limit my spontaneity.

PALETTE

Although there are palettes designed for acrylic paint on the market, I find air-tight kitchen containers most satisfactory. In any case, the palette should be made of a material that is impervious to acrylics. Most plastic surfaces, for example, will not allow acrylic paint to adhere permanently; the dried paint film can then be peeled off periodically to clean the palette. It is also important to have an air-tight cover so that the paint will not dry between painting sessions. The size depends on how many colors the palette must accommodate.

WATER CONTAINERS

A small water container fastened inside the palette allows one to moisten paints to the proper consistency easily. One should also have a separate large container of water nearby for rinsing brushes.

The drier the air in the workspace, the faster the paints will dry. Periodically one may use a pump spray or atomizer, like the kind used to mist houseplants, to moisten the palette and keep the paint from drying as one works. Be sure the atomizer sprays a fine, even spray. It can also be used to moisten the painting surface evenly to retard drying.

If acrylic paint accidentally touches any surface, spray it with water immediately before attempting to remove it. Paint can be removed from a nonabsorbent surface most easily by spraying and then wiping the surface with a clean, dry cloth or paper towel; repeat this several times to remove the slightest stain.

BRUSHES

Different brushes do different things, and even brushes of the same type may have different characteristics. And as brushes get used, their characteristics change. A brush that works well for foliage today may not work as well tomorrow. As different problems occur during the painting process, I often change brushes, taking advantage of their individual characteristics.

In general I prefer Kolinsky red sable watercolor brushes for painting with acrylics. These give the greatest amount of control and responsiveness to touch (provided that one's paints are of the proper consistency), and they provide the fewest surprises in handling. With varying pressures, brush angles, and up-and-down movements, they can produce a great variety of brushwork. Depending on the pressure, they can go from a thin line to a wide one, covering the surface, without push-ing through the paint—unlike stiff bristle or nylon brushes, with which the hairs will push through the paint to reveal the surface. (Nylon brushes, however, are useful for working large areas of color evenly on a somewhat textured painting surface, as they push the paint into the crevices.)

For my small paintings, I use primarily the no. 1 sable, which is excellent for even the smallest detail. Generally I do not need a smaller brush, except for painting a very fine line; then I may switch to a no. 0. For larger paintings, one might use a no. 3 or 4 red sable, depending on the relative increase in the size of the shapes.

Red sable brushes are durable and need no special care other than rinsing in water and periodic washing with soap. If they get a little dirty, the hairs may separate when one tries to paint a line. Also, if paint dries at the very tip, it may inhibit the paint flow. Occasional paint buildup around the ferrule can just be peeled off.

During normal use, hairs will come loose, and this will alter the way the brush works. Although trimming a brush is generally not a good idea, as this disturbs the brush's natural shape, stray hairs *do* need trimming.

RULING PENS

At times—for example, when painting architectural structures—one may want to create very straight lines and precise edges. Acrylic paint can then be used in a ruling pen and applied in the same way as ink. With the ruling pen, one can draw any straight line of any width, without variations in thickness. For many paintings, however, ruled lines may be too straight—so the ruling pen must be used with discretion. Also, the ruling pen can create a three-dimensional line if the paint beads up, so its line may stand out from the rest of the brushwork.

MASKING TAPE

Another way to create a straight edge is with masking tape. It can be applied on any surface, rough or smooth. After the tape has been laid in place, one should apply a layer of gel medium over the edge to be painted. Doing this keeps the paint from bleeding under the edge of the tape; although the gel itself will bleed under the edge, it is transparent and will not show. One can then simply paint the desired color and peel the tape from the surface.

PAINTING SURFACE

Acrylic paint can be applied to any surface that will hold acrylic gesso—hardboard, canvas, or paper—although it is not necessary to use gesso on paper.

Both tempered and untempered hardboard may be gessoed to the desired texture. However, one takes a chance in working with tempered hardboard, which is impregnated with oil for exterior use. Untempered hardboard is more absorbent than tempered hardboard, and so more of the gesso will be absorbed into its surface.

There are advantages to each kind of texture, from rough to smooth, so it is important to experiment with a variety of surfaces. To create a consistent surface texture, for example, one might apply gesso to the hardboard with a paint roller, preferably a short-haired one. One can also vary the amount of water used with the gesso. Once dry, the first coat of gesso can be sanded or re-gessoed. It may take some practice and experimentation, however, to get just the surface one wants. With an orbital sander, one can develop a surface that resembles a smooth plaster wall, for example.

Canvas can also be worked with gesso to develop any texture. It has an advantage for large acrylic paintings. The texture of the canvas, along with that of the gesso, can actually hold a wash; also, large

areas of a single hue can be applied without showing brushstrokes or the direction of the brushing. In this way one can put down a new mark of a particular hue next to an area of the same hue without a visible break in the color.

With paper, gesso may be used, although it is not necessary. There is an advantage to using gesso, however: a gessoed surface will not absorb the water, and the paint can be manipulated more easily. Without gesso, acrylic can be applied to the paper much like watercolor, gradually building up the paint body. The final image on ungessoed paper tends to appear somewhat dry compared with the slicker quality of a nonabsorbent surface.

I like to use 300 lb. hot-pressed watercolor paper because of its smooth surface. I find that any texture on the painting surface catches shadows and interferes with the detail in my paintings. I prepare the paper by submerging it in water for at least ten minutes; then I staple it to a board. I sometimes wash in the skies while the paper is still wet.

CHAIR

Because most of my paintings are small, I like to work seated. I use a comfortable armchair that allows good posture. My arms need to be relaxed, and my head must be able to assume a normal position without pulling on the neck muscles. When one spends hours a day painting, posture and relaxation become very important.

"EASEL"

When I work on a small painting, I simply rest the painting surface on a pillow on my lap. The pillow allows me to adjust and move the painting surface about freely, depending on the area that I am working on. An important advantage of the pillow "easel" is that it allows me to make fine adjustments to avoid glare on my painting surface. Sometimes I

SLIP KNOT TO ADJUST HEIGHT

SLIP KNOTS TO HOLD PAINTING

My rope "easel."

prop my feet on a platform to raise the position of the painting.

For larger paintings, I have devised a rope easel, which is tied to the ceiling with a slip knot so that I can adjust the height and angle of the painting (see the illustration).

POSITION OF THE PALETTE

The palette should be held as close to the painting surface as possible to aid spontaneity. An awkward posture can inhibit one's working procedures. I hold my palette in my left hand, directly under the light, and rest it on the arm of my chair or on the front portion of the pillow easel, in front of the painting.

LIGHTING

It's a good idea to paint under a light brighter than any light the painting could be exhibited under, so one can see more than the viewers will. Fluorescent lighting works best for me. I find that if the painting works well under this cool light, it will appear warmer under balanced light. Another advantage of fluorescent tubes is that they are not as hot as conventional bulbs and thus do not dry the paint on the palette.

WORK HABITS

Perhaps it would be a good idea to mention something here about work habits. I am often amazed at the difficulty experienced by people who say they want to paint but somehow can't seem to get around to doing it. Often they are not sure what to paint, and they feel that if they just had the right subject matter, the painting would come more easily. What these people fail to comprehend, because they haven't experienced it, is *commitment*.

If you are a committed painter, you do not think of when to paint; you just paint. Commitment means that, when you walk by your studio each day and see your paintings advancing toward completion, you are so involved with them that you are not even sure when the painting process is actually taking place.

All of us have different capacities for commitment. Merely having the skills to paint is not enough. It helps to believe that doing a painting will be worth the effort, or that the painting process is simply enjoyable—more enjoyable than most other things. Some people work primarily for recognition; being a successful painter is one way to set yourself apart. Some people approach painting more simply, the way a cabinetmaker approaches his or her work: it is what they do; they do it best; and they feel best when they are doing it.

In my own painting I am motivated by working with ideas that I feel comfortable with but that also take me somewhere new. These painting ideas are ones that I find elevating spiritually and inspiring to look at. Simply doing realistic painting does not mean that much to me; I have to have a better reason to paint than doing a convincing image.

I also am interested in communication. It means something to me if the paintings I feel strongly about are the same ones that other people respond to enthusiastically—both those who know something about art and those who know the least about it. The viewer's response has been a strong motivation for me.

Like most other painters, however, I also have motivational slumps. I generally try to prevent them by demanding more of each painting that I do, trying to push the ideas a little further each time. Probably the most important thing I do to improve my motivation is to work on several paintings at one time. There are times when I don't want to have to think too much or tackle something I haven't tried to do before, so I'll look around for some "dumb" work to do. If several paintings are in progress at one time, usually one will be at a stage where it requires work that is time-consuming but otherwise less demanding. It may involve laying in a large patterned area that has little variation, for example. There are other times when I feel like doing trees or blocking in architectural forms. Sometimes I am in a "finishing" mood and want the satisfaction of sharpening an image to its final look. Sometimes I want to be involved in the most exciting stage of a painting—developing the image on the painting surface, which I often call the "setup" stage—and in a matter of minutes, I can often see the general shape of my final painting.

In addition to working on several paintings simultaneously, I like to have a few new ideas kicking around in the back of my head for the future. I spend a great deal of time conceiving paintings, working out some of the problems in my head before I ever commit myself to the painting. I do this by comparing my idea to other painters' solutions to similar paintings. By the time I begin the actual painting, I have worked out some of the "bugs." Also, I may introduce part of a new idea into a painting on which I am currently working, to try it out and assess other people's reactions to that part of the painting. While I always have a strong notion about what I want out of my paintings, I also spend a lot of time listening to viewers' reactions to them.

Another aspect of my way of working might best be described in terms of current ideas about the different functions of the brain's left and right hemispheres. I have discovered that I can do all kinds of left-brain things at the same time that I am painting. The part of my brain that makes decisions about the painting can soar while my conscious mind is dealing with other things. I often watch movies, and sometimes even have deep conversations, while I paint. I also do a lot of serious thinking, mixed with thoughts of a more ordinary nature, while painting—I may solve other painting problems, or think about teaching—because my creative side seems to be on automatic pilot.

While I like to occupy part of my mind with other things as I paint, that is not necessarily the right thing for every painter. Whether quiet or stimulation augments concentration is a matter of individual temperament. The main thing is to use whatever it takes to enhance one's involvement in painting.

THE PROPERTIES
OF ACRYLIC

Because acrylic is a relatively new medium, there is no tradition of knowledge about how to use it, as there is with watercolor or oil. Acrylic can in fact be compared with both watercolor and oil, as it shares some of the characteristics of each. As an "aqueous" medium, it is frequently categorized with watercolor in exhibits.

When the painting surface is canvas, acrylic is likely to be used as if it were oil; when the surface is paper, it is often used as watercolor. But acrylic also has special properties of its own that deserve consideration. The ways in which it differs from both oil and watercolor—which some painters might consider liabilities—have become, for me, major assets.

Traditional oil painters may be bothered by acrylic paint's thinner body, which affects both its workability and its appearance. Because of its thinner consistency and greater transparency, acrylic may suggest a lack of substance and physicality in the paint surface; acrylic paint will not appear to have much body unless fillers are added. Moreover, for the traditional oil painter, the lack of resistance as the paintbrush pushes against the paint may reduce the quality of the painting experience.

Because it dries so quickly and thus presents fewer transportation and storage problems than oil, acrylic is sometimes recommended for student work. But acrylic's rapid drying time may also beset the newcomer with problems. Unfortunately, too many teachers and painters are oriented toward applying oil painting methods to it. Indeed, when acrylic was new, there was much talk about using retarders to make it behave like oil.

Artists with an oil painting background tend to anticipate having more time to work with the paint, light into dark or warm into cool, before it dries. Working wet-on-wet with acrylic requires a clear idea of where you are going; only the most disciplined painter can be successful with this method.

The key to dealing with acrylic's fast drying time is learning to work with it, not against it. From this perspective, its drying speed can be a major advantage. Combined with the permanence of the paint film when dry, it permits working and reworking, over and over. Many layers can be established in a brief period of time. And, early in the painting process, one can develop not only form but also very complex surfaces by smearing and dabbing layer over layer.

For my work, the consistency of the paint is critical. I do not find it necessary to use medium or gel; instead, I prefer the paint to flow as it can only with the addition of water. Given the paint's consistency as it comes out of the tube, as well as the fact that the paint is always drying, mixing the paint with water is an ongoing process as I paint. I dip the brush in the water regularly and spontaneously. Sometimes a hue can be mixed without adding water, but then I add water to make it the proper consistency just before applying it to my painting surface.

In addition to the paint's fluidity, the absorbency of the painting surface affects one's spontaneity in developing a painting. If the surface is too wet, details spread and the light-dark definition does not develop properly. On the other hand, if it is too dry, it absorbs the paint too quickly for one to manipulate surface patterns.

In sum, what I like about acrylic is the speed with which it allows one to develop an image and the way one can build an illusion through transparent layers of paint. These advantages are greatly enhanced by strong drawing and the ability to mix color spontaneously, with control of the consistency of the paint.

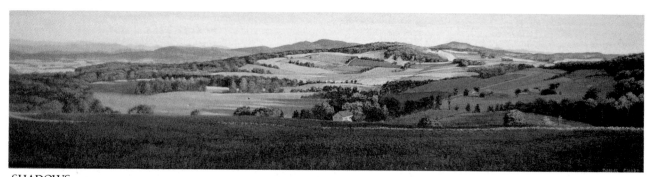

SHADOWS
1983, acrylic on paper, 3″ × 13″ (8 × 33 cm),
private collection, courtesy of O.K. Harris Works of Art

BRUSH TECHNIQUES

The kind of imagery possible with my painting methods is directly linked to knowing what brushes can do and how to handle them. Some of these techniques are illustrated here. But keep in mind that it takes practice to develop skilled brushwork with acrylics. To really understand what brushes can do, one must do a lot of painting.

If one hair is sticking out at the end of a brush, acrylic paint will dry on it, restricting the flow of paint when the tip is used. Sometimes the restricted paint flow will interfere with the painting process before the source of the problem is identified. A slight magnification, however, will easily reveal the paint buildup. Usually paint buildup can be washed off, and a protruding hair can be trimmed, provided the overall shape of the brush is good. When a brush loses its shape, it's often because it needs cleaning rather than trimming.

If the paint is thin enough, it will flow down through the hairs of the brush with the help of gravity.

The tip of the brush is difficult to control for fine lines. Instead, the paint should be "trailed" with the brush held at an angle—that is, with more brush touching the surface.

Putting pressure on the brush adds width to the line by forcing the brush hairs to spread.

For clear edges, paint with one side of the brush.

A physical edge can be constructed by rolling the brush toward the edge during the stroke.

Brushwork should take advantage of natural hand movements. Often difficulties with brush control arise from working against these natural movements.

This photograph shows up and down movement, pivoting at the wrist—much like the action of a sewing machine. By combining this movement, as well as slight lateral movements, with different brushes and paint consistencies, one can develop a variety of textures and patterns.

A lateral brush movement pivoting from the wrist allows one to paint a regular horizontal line with ease. To ensure the regularity of the line, the hand and fingers should be nearly frozen.

Lateral movements pivoting from the elbow are also useful in painting regular horizontal lines.

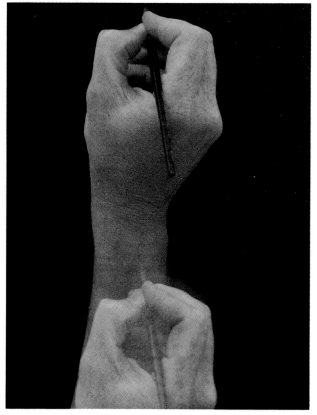

Here the movement is from top to bottom, pivoting from the shoulder. This movement can be effective in creating a regular vertical line, pulling the paint down the surface.

An intense involvement in the act of painting can lead anyone to develop special techniques, distinguishing his or her work from that of other artists. I didn't set out to discover the finger techniques I use—they simply emerged out of the painting process. I was working on a small scale, smearing and dabbing the paint, when I noticed that this resulted in different textures. Grass, in particular, seemed an area where one could develop an almost analogous image with finger techniques alone. Eventually I found that many areas were enhanced by using the organic textures created by this method—either alone or in combination with brushwork. The examples here present a few of the diverse possibilities.

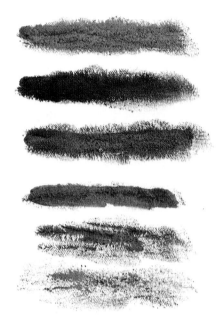

These examples show how the consistency of paint alters color and pattern.

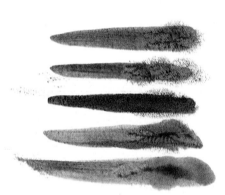

Paint can be applied with varying consistency. The paint is smeared to the right to squeegee excess water. The right side of the smeared stroke is tapped with the thumb, which creates a diagonal pattern.

The amount of water in each of the strokes here is evident in the subtle pattern of the smear. The top example is of medium consistency. The second stroke contains more water, which can interfere with the development of a pattern. When the paint is too thick, as it is in the center stroke, it completely covers the surface and creates a very fine pattern. Sometimes this may be desirable. But in situations in which one wants to gradually build up patterns—for example, when painting grass—an initial layer of paint of this thickness would be unworkable. The bottom two strokes have too much water; they need to be squeegeed again to create a pattern.

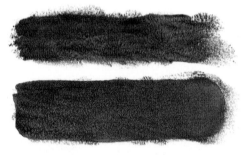

One of the great advantages of finger techniques is that large areas of organic pattern can be developed consistently. As the surface is blotted repeatedly with the fingers, the pattern becomes very fine. The result is a surface that is visually active and relatively even.

The transparency inherent in finger patterning allows underlying colors to show through, as with the blue in this example.

Here brushwork has been added to finger patterns on the right side to further articulate the pattern.

If brushwork is used to reinforce and develop organic finger patterns, it has to be organic itself. It must coincide with existing patterns and should be as free and spontaneous as a doodle.

Color can be washed over organic brushwork to unify the pattern with the rest of the painting. A wash will also reduce the contrast within the pattern and, to varying degrees, darken the pattern.

Using light on dark or dark on light, finger techniques can be used to develop horizontal patterns that work well in representing water.

Brushwork can be applied on top of horizontal finger patterns to further the analogy to water. Here the horizontal patterns were developed largely by smearing the paint. In the second example, a wash was applied to the extreme right to unify the pattern. Additional washes and brushwork can be added until the pattern is satisfactory.

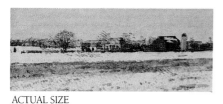

ACTUAL SIZE

The background trees were created by tapping a thin drop of paint with fingers. At first glance the resulting pattern suggests a lot of detail, with delicate branches, but a closer examination reveals that the trees are parts of fingerprints. Finger tapping was also used to create the organic pattern in the foreground.

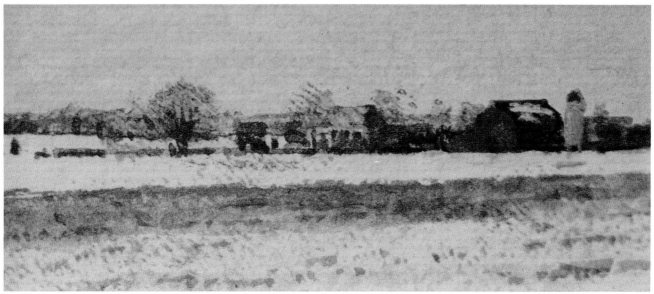

ENLARGED MORE THAN THREE TIMES

LAYERING
WITH ACRYLIC

Through the layering of successive washes and patterns, acrylic paint has a unique ability to imply volume and surface complexity, as well as density and luminosity. There is a possibility of a complexity that is infinitely diverse, just as nature is—a distinct advantage for realistic landscape painting. Such a complex illusion, however, requires more than just two, three, or four transparent layers of paint.

Essentially, my approach emphasizes value and pattern more than color, since with acrylic, the color can be washed in over this base at any time. By layering over and over again, as shown in the examples here, one can build surfaces with many subtle value differences—and one can do this more quickly with acrylic than with other media.

Developing images in this way requires some planning and a sense of where you are going, but the rewards are great. Acrylic's natural transparency, particularly when it is mixed regularly with water to maintain a fluid consistency, allows the initial underlying patterns to have an effect on the surface even after many layers have been applied. The degree of working and reworking possible with acrylic would be difficult with watercolor (due to the vulnerability of both the paint and the painting surface) and impossible with traditional *alla prima* oil techniques.

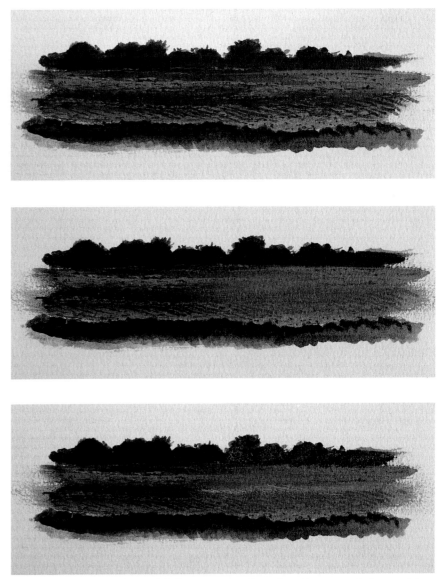

If the water in a scene is clear and shallow, one approach is to begin by painting the bottom of the stream or lake. In this illustration, for example, the bottom is first defined with gray-browns and developed with finger patterns.

A brown wash is then smeared over the pattern to unify it and indicate the water's surface. This kind of smearing can suggest perspective if care is given to its direction.

In the final step shown here, finger patterns are again used to define the surface and suggest the water's texture. On the right, the illusion of white water is created by finger patterns reinforced by a brush.

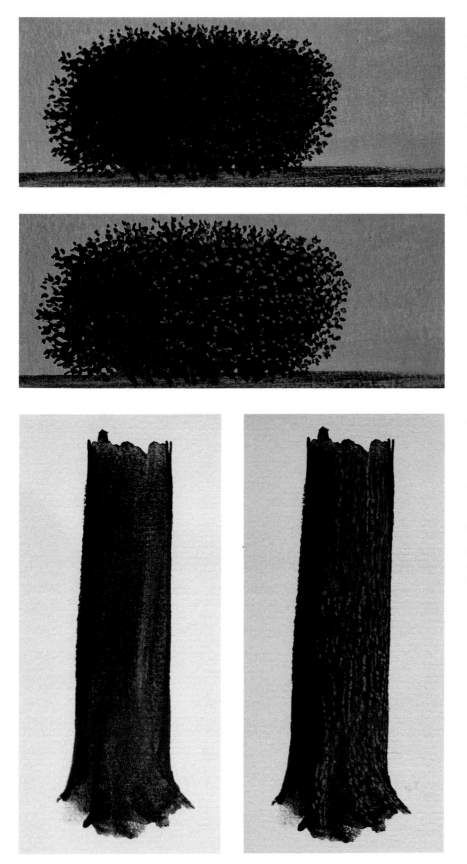

The silhouette of the bush is defined with a dark color made up of black, green, and raw umber. Careful attention is given to the edge. A lighter green is used in the interior to indicate something about the direction of light and the volume of the bush.

The illusion of density, complexity, and volume in the bush results primarily from a repetitive process of defining the leaves and then washing over them. Each wash tightens the value range, making the differences between values more and more subtle. The layering of brushwork and washes makes the surface very complex, suggesting much more than would be possible with straightforward brushwork.

A similar layering technique is used for the tree trunk. An initial smear of brown and black is made in a vertical direction, following the trunk. The darker paint on the left side suggests volume from the very beginning. There is also some suggestion of texture from the smearing.

A thin light brown is then applied with a brush in an organized pattern. Next, darks are applied to define the grooves in the bark. Finally, another gray-brown wash is smeared over the surface to unify it, while allowing some definition to remain. This process could be repeated for greater complexity.

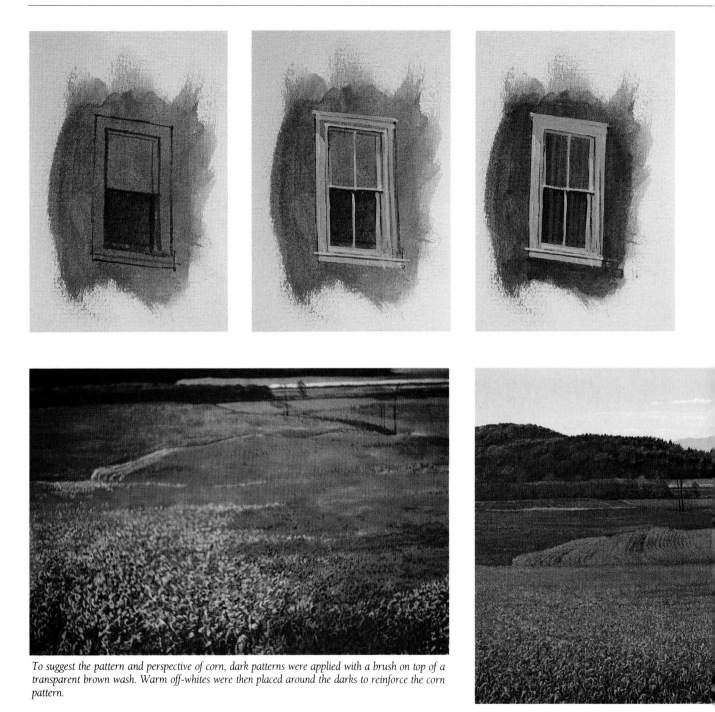

To suggest the pattern and perspective of corn, dark patterns were applied with a brush on top of a transparent brown wash. Warm off-whites were then placed around the darks to reinforce the corn pattern.

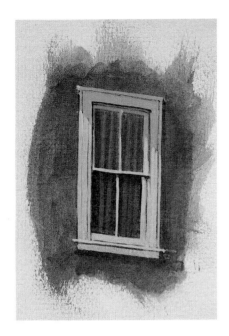

This window is built up on a gray-brown wash. Once the shape is sketched with dark paint, the white planes are layered to indicate the various facets of the window. One stroke of a thin white produces a light value. When the same thin white is stroked over this surface, after it has dried, it becomes lighter—that is, the lightness can be increased by layering the same value of white, provided the paint dries in between. The window can then be painted much as it is constructed, board by board—with each stroke representing a board.

CORNFIELD
1983, acrylic on paper, 8″ × 24″ (20 × 61 cm), private collection, courtesy of O.K. Harris Works of Art, photo by Benjamin Fisher

After the basic corn pattern had been suggested with darks and lights, thin orange washes were laid in; then a succession of washes and reinforcing brushwork was used to further develop the corn. The final touch was a layer of off-white applied with a brush.

MIXING AND
MATCHING COLOR

For the painter, the most basic knowledge of color emerges from mixing and matching colors on the palette and the painting surface. Unfortunately, some realist artists try to use color too symbolically, depending on their knowledge of an object's color to carry the image without discriminating its value and temperature. Other artists may be aware of value but use color solutions that are too consistently monochromatic—which, in most cases, comes close to having no color at all. Another difficulty arises from using the same palette for most paintings, instead of letting the subject determine the coloration.

One of the most important things to learn is that color is *relative*. There are no absolutes. The visual effect of a shape, pattern, value, hue, or any other element depends on the context in which it is seen. An artist should not add a value or a hue to a painting without considering its effect on existing values and hues—and vice versa.

Another point to remember is that the effective description of a landscape image has to do with the description of contrasting values. That is why color mixing should involve a continual re-examination of values—whether by using black, white, or complementary colors. In creating a convincing realist image, it is most important that there be subtle value discriminations in patterns and between shapes.

Unfortunately, color is often perceived before value, and many people have difficulty discriminating between the relative values of strong hues. Moreover, all too often painters develop the ability to depict values in black-and-white pencil drawings but fail to transfer this skill to the painting process. Different tools are used in drawing and painting, and there is a difference between the process of cumulatively building up graphite to establish value and mixing and matching paint. Color can be distracting in attempting to control value. Doing a strictly black-and-white painting is one way to develop skill in working with value.

In addition to value, temperature—the warmth or coolness of a hue—is an important consideration in landscape imagery. It is particularly important with acrylic because a hue can be enhanced so easily with washes after the image is developed.

Warmth or coolness can be enhanced or reduced by adding complements. This builds contrast into the color variations in a painting and helps avoid a monochromatic look. Working with temperature then improves the subtle discrimination between colors and increases the variety of color within a particular hue range. With foliage, for example, having a variety of greens—from yellow-greens to blue-greens—provides a more believable representation.

Temperature is also a major consideration with grays and off-whites. Too often these are neglected as colorless, but their warmth or coolness can affect their fit in a painting. An example would be the shadows on a white house—the slightest mistake in temperature can cause them to separate.

An awareness of color temperature is particularly helpful in controlling color mixing. This knowledge can enable one to determine which color will affect real change in a mixture, or how specifically to correct a mismatch. If, for example, one is working with phthalo blue (a cool blue) and ultramarine (a warm blue), there are things one can and can't do with each because of the temperature. Phthalo blue can't be made into a purple, for instance, because of the green in it, while ultramarine can't be used easily for greenish foliage because it has too much red in it.

Locating the complementary color that will neutralize, or gray, a particular hue helps to reveal the hues making up that color. In trying to neutralize a blue, for example, one might try an orange. But if the blue is a greenish blue and one does not mix a reddish orange, the blue will become even greener, thus revealing its difference from a pure blue.

Since acrylics dry darker than they appear when wet, mixing and matching colors may present a problem for someone who has never worked with them before. It can be a surprise when, after washing in a light blue sky, the color dries much darker. Trying to match the hue and value of a tint can be particularly difficult because we make more value discriminations with tints than shades.

Matching color mixtures made with two colors may seem manageable, as one can achieve a certain amount of success through trial and error. But when one adds a third hue, the solution may seem out of reach. With practice and a good eye, however, one can eventually learn to match almost any color—anticipating for the darker drying. Nevertheless, if one expects to reuse the exact same tint later in the painting process, it's a good idea to mix some extra paint and save it for future use.

In my own work I rarely premix paints for use throughout a painting. Instead, I continually mix and remix colors as I paint, making color adjustments throughout the painting. This method encourages flexibility and keeps the painting alive, in a state of flux.

Resolving the color in any particular area usually involves working into the area with warm and cool colors, as well as light-on-dark and dark-on-light values. As I work, the color effects in the entire painting are continually modified. The existing visual effect of the painting must be understood, and then the paint must be mixed and worked into the surface to modify the color temperature, pattern, unity, contrast, or other aspects of a given area to achieve the desired effect.

PHOTO-EXTENSION EXERCISE

With any medium, a sense of play is important for successful painting, but the artist also needs good control. Realist painters often push the analogy to reality in their imagery only so far, without challenging their conventional ways of creating imagery. Weak paintings may also result from poor reference material or a lack of information about the subject. The painter just fills in what is not available, making generalizations about the subject. Working directly from a photograph can make the painter more accountable.

With this in mind, I recommend the photo-extension exercise to students as a way to check and sharpen their painting skills. The goal is to extend half of a photograph with paint, using the other half for reference. Looking at the finished exercise, the spectator should first see the combination of images as a single image, rather than as a split image—half photograph and half paint.

The directions for this exercise are relatively simple. Choose a good-quality photograph (from a good-quality magazine) with high resolution and with the smallest dimension at least 4 inches (10 centimeters). In general, photographs of interiors work best. In any case, try to exclude people because they introduce an additional, unnecessary problem.

The photograph should be varied in color, value, temperature, shape, and pattern. Avoid photos with large plain areas or solid blacks for shadows (textures in the shadows should be seen). For a good sense of volume, an angular perspective and side lighting are advantageous.

Cut the photograph in half (in any direction), right through the busiest part of the image. Fasten half of the photograph to a piece of smooth illustration board with paper cement. Keep the other half for reference. With paint, extend the cemented half of the photo to complete the half that was cut away. Acrylic or gouache paint will work best.

When the photo-extension is completed, it should not be immediately clear where the photograph stops and the painting begins. This is largely a problem of making visual discriminations, mixing and matching paint. Most people with modest visual skills can eventually complete the exercise with some success. Anyone can see if it has been done successfully. Completing this exercise, of course, doesn't mean that great painting is now at hand. But it does mean that the potential is there for believable imagery.

Susan Bowe, **STUDENT EXERCISE**

The sooner the desired image emerges—with shape, volume, and contrast—the sooner it can be dealt with as a painting. This means that the image has direction, that future marks can be set into an existing framework with meaning and purpose. It also means that additions to the image take on value because they exist within an elaborate context.

It is not new to say that a painting should be developed as a whole. But, to realist painters, the idea of establishing the whole image early in the painting process is problematic. Too often, early in the painting a specific area begins to take on undeserved emphasis, and the rest of the time is spent trying to bring the painting back into control.

The demonstration on the next few pages shows how a painting can be developed and controlled at the same time, while working with a clear image. I have chosen a photograph with variety and contrast as a guide and developed the image in just a few steps. Although the result is not as detailed as my finished paintings, it is a well-established image that reflects the look of the original photograph.

REFERENCE PHOTOGRAPH. The composite photograph shows a landscape with a distant vista. The immediate foreground is dominated by a grassy plane that is half in shadow, bleeding off the bottom of the photograph. A wall of corn extends laterally across, showing some perspective as it moves away to the right. The highlighted corn tassels create a textured band of yellow-orange, which contrasts with the darker green stalks in shadow and the soft green fields in the middle ground.

Much of the middle ground is in shadow, except for the tops of the dominant trees. Behind the shadowed middle-ground area are bands of illuminated fields of corn, broken up by the large trees in the middle. In the far distance, the forests and fields are softened by the atmosphere.

The textures and shapes of the fields help describe the direction of the planes. The overall shape of the horizontal plane is quite varied, but it is clearly visible, from the foreground to the background.

STEP 1. Rather than develop a drawing for this particular image, I use an opaque projector to locate the shapes on the paper. There are many ways of getting an image from a drawing or photograph onto the painting surface. Slides, an opaque or an overhead projector, and the traditional grid are common methods. Some people have problems with these methods philosophically, but I do not. A good painting is a good painting regardless of its sources. Poor draftsmanship cannot be camouflaged by mechanical means. Often, complaints about the process used to develop a good painting reflect more on the critic than on the painter.

In the drawing I outline the edges of things so the planes can be washed in, to the edges. Then I apply a light blue, semi-opaque wash of acrylic, overlapping the horizon.

1.

2.

3.

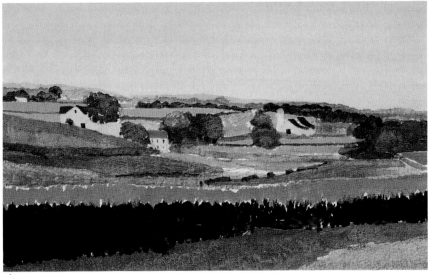

4.

STEP 2. I use a thin, gray blue-green for the horizon and vary the horizon line for interest, reflecting the natural diversity of the landscape. Because acrylic paint dries darker, it is easy to get too much contrast against the sky. Keep in mind that the closer the values of the sky and the horizon line, the greater the distance implied.

My next consideration is for what goes on in front of the horizon. Here I apply the paint thinly and tap it with my fingers to create a surface pattern. I add other greens to represent the green fields and the edges of the cornfields (the stalks), keeping the greens in the shadows darker.

With the middle-ground trees, I again tap the paint with my fingers to simulate the organic pattern of the foliage. The edges of the trees are kept irregular. I apply another layer of paint to the grouping of trees on the right to indicate some volume—smearing and tapping the paint with my fingers to keep it from going flat.

STEP 3. Adding the yellow-orange provides a natural warm-cool contrast. I also add the next layer of trees to the distant vista, keeping the patterns organic. In the foreground, I brush in the cornstalks generally to imply the pattern, giving attention to the top edge of the stalks.

Notice the shadowed cornfield at the left of the middle ground, which is treated with orange and then a gray-green, tapped with my fingers. The general slope of the hill is indicated by the direction of the subtle pattern. Also, the field is divided by applying the gray-green in two stages; the overlapping of these two transparent layers creates the division in the pattern.

STEP 4. Buildings can reinforce the vertical and horizontal structure of an image, giving more leverage to slight variations in the verticals and horizontals. After painting the overall shapes of the buildings, I add roofs, doors, and windows to provide structural reinforcement. Not only does this make the buildings look more like buildings; more important, it contributes to the overall structure of the image.

Now I wash in the remaining fields and the foreground band of corn tassels, which curve back into the middle of the image. After thin washes are applied to the remaining white spaces, the foundation of color and pattern is complete. Decisions about contrast now need to be made.

STEP 5. To bring more attention to the illuminated cornfields in the distance and the corn tassels in the foreground, I smear a wash over the middle ground. This unifies the area as shadow. Much definition has been lost, however, and it will have to be re-established.

Next I darken the middle-ground trees and lay shadows across the corn on the right. The trees just in front of the horizon also receive another layer of paint. The texture that was there was not really justified, given the distance from which they are seen. Finally, on the far right, I add a grayish yellow ochre shape above the dark trees. I also add some hedgerows for greater definition.

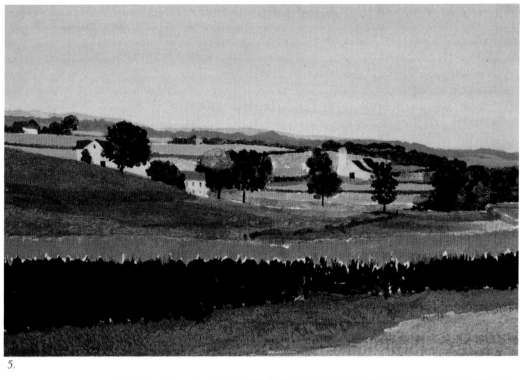

5.

STEP 6. Most of the decisions between the last step and this one concern contrast. I re-establish definition in the middle-ground shadows, providing more volume. Similarly, in the foreground, I add darks to the shadows in the grass and work the cornstalks up into the orange. The highlights (dabbed for texture) in the middle-ground trees and the white spaces (suggesting architecture) in the distant vista also provide contrast.

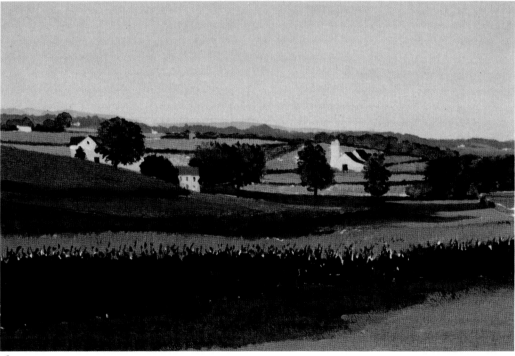

6.

A SPONTANEOUS APPROACH

The process of laying in the basic composition of a painting can be accomplished in minutes, and it quickly provides a good idea of the painting's direction. A cursory glance at the lay-in for *Gardiner Farm*, for example, shows important similarities to the final painting. Many major decisions—which will shape the final painting—are made at this early stage, when it is easier to think of the whole than the parts, and changes can be coordinated with the entire image. At this stage twenty percent of the total time spent on the painting may affect as much as eighty percent of the image; after the image has been established, on the other hand, the remaining eighty percent of the time may be spent on only about twenty percent of the image.

Gardiner Farm is a documentary painting, in which I used photographs for reference and remained faithful to the farm's appearance. There are, however, subtle differences between the photograph and the painting. For example, the middle ground in the painting is farther away and the trees above the horizon show greater variety. Also, the buildings of a shopping center on the left have been eliminated, leaving a gap in the trees through which a distant vista can be seen.

In terms of structure, the horizontal plane, which occupies almost two-thirds of the painting, is emphasized, and the sky is de-emphasized, as it is underdefined. There is much energy from the strong receding movements on both sides. This energy is con-

tained by the tautness of the horizon, which forms the back edge of the horizontal plane and connects the painting laterally. The varied lights and darks along the top of the horizontal plane also connect the two sides. Turning the painting ninety degrees may make it easier to observe the importance of the horizon and the activity along it.

The two focal points are developed differently: on the left, receding patterns of brown and green lead to an area in the distance but not to a specific point; on the right, the sandy road takes a couple of bends defining the horizontal plane as it moves toward the buildings. When the reverse image of the painting is studied in a mirror, it is clear how the right side turns the eye back toward the other side.

The small size of Gardiner Farm *allowed me to take a spontaneous approach to its development. Many finger techniques were used to establish the general look of the final image very quickly.*

After this brief analysis of the mechanics of the image, I must explain that very little of this was preconceived. The freedom with which I used the paint allowed many of my compositional solutions to emerge naturally out of the painting process. I did not, for example, consciously consider the left-right movement in the painting until I started writing this statement.

How, then, did I proceed? To begin, I painted the sky in one shot, gradating it as I worked. I guessed at a good general location for the structural horizon and began washing, smearing, and dabbing in the colors to define the horizontal plane. I laid on thin paint with a brush and then smeared and squeegeed it with my fingers. Before this paint was totally dry, I added texture with my fingers to keep it from going too flat. If the surface was to be complex, I had to build the complexity from the beginning with every application of paint, each new layer reinforcing the already-established patterns. The spatial direction of the patterns on the ground plane was foremost in my mind.

Next I redefined the structural horizon as a base for putting in the trees. I laid in the dark evergreens with a brush, emphasizing their edges against the sky. I also brushed in the distant vista on the left with a light gray-blue. The trees on the

GARDINER FARM
1986, acrylic on paper, 3″ × 13″
(8 × 33 cm), private collection,
courtesy of O.K. Harris Works of Art
(reproduced larger than actual size)

This distant vista was fabricated to replace the shopping center in the original photograph. It augments the feeling of space without disrupting the importance of the horizon line.

right were laid in with a thin wash of a dark value and then dabbed to allow the white of the paper to come through. (The paint has to have just the right amount of water for this.)

To imply the filigree-like silhouettes of the deciduous trees, I applied further dabs of paint over the sky and then added trunks and branches into these soft patterns. Next I reinforced the horizon under the dark evergreens. As the buildings on the right were added and the road suggested, I understood the need to make this road define the fields as well as the tilt of the horizontal plane.

The final painting maintains the structure of the horizon while diversifying the manner in which it is described. The orchard trees provide additional horizontal movement, as does further development of the fields close to the horizon. At the same time, the orchard trees are grouped on a grid that defines their location and provides a sense of volume between their front edge and the horizon. Some peach trees overlap the dark evergreens, demarcating an interval of space.

The texture of the foreground is varied, adding some interest to this area. As the horizontal plane approaches the bottom, however, it drops off and flattens. This helps to concentrate the illusion of depth and the overall energy of the painting along the horizon.

Implied ruts and tire tracks define the road as it moves toward the house. Its angular bend helps to define the horizontal plane and leads the eye across, to the other side.

DEVELOPING
A PAINTING IDEA

Among the many reasons for choosing a painting subject is how well it serves as a vehicle for compositional ideas. My first landscape paintings emphasized the horizontal, through a panoramic format. I thought of these works more as images than as paintings. As I began to do occasional paintings with a less elongated rectangular format, the picture space called for greater structural consideration. Currently, the raison d'être for my major paintings is structure and the equilibrium between two- and three-dimensional space.

Most recently I have become interested in backyard scenes—an interest that began with *Pittsford* (pages 76–77). Something in my own experience was triggered by the sight of a backyard with shade trees and unpretentious architecture.

In *Alloway* I undertook a major exploration of this idea, and almost everyone who saw the painting liked it. I didn't trust it myself. I thought it could well have been a bad painting that everyone liked—a prospect that seemed almost as unpleasant as doing good paintings that no one liked or understood. I did not immediately jump to do more paintings like *Alloway*: I looked at the image and thought about it for a long time. Occasionally, I would flirt with the idea in one of my distant-vista landscape paintings. In the autumn of 1985,

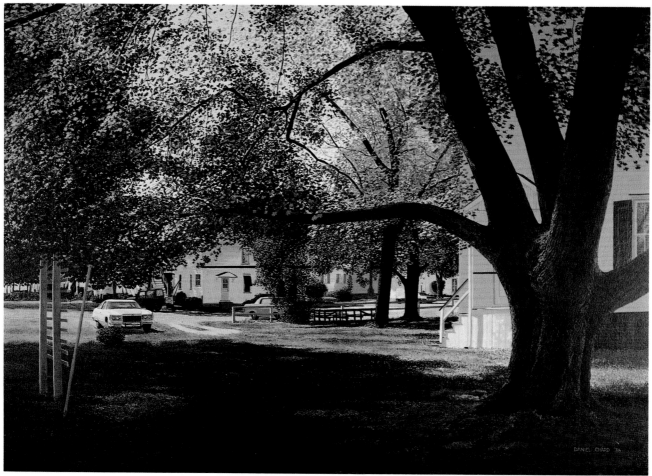

ALLOWAY
1984, acrylic on paper, 19″ × 27″
(48 × 69 cm), private collection,
courtesy of O.K. Harris Works of Art

The large areas of foliage and shadowed grass provide a visual frame, dramatizing the details in the center. A similar kind of contrast was used in Brick House *(pages 96–97), with similar results.*

however, I made another major foray into my "backyard" idea. I had been looking at many potential subjects, and I took scores of photographs of them for possible paintings, trying to understand the basic idea better.

Each of the paintings that has developed from my general back-yard theme has certain fundamental elements: foliage, architecture, and a strong sense of the horizontal plane. There is almost no distant vista, unlike my previous landscapes. The foliage most often dominates the sky, and the scene is usually backlit, with long shadows defining the horizontal plane. Much of the fore-ground—both the foliage and the horizontal plane—is in shadow.

The volume of the scene is laid out like a stage-set design, with clear intervals between spaces, both two- and three-dimensionally. Angular perspective adds energy to the im-age, providing strong diagonals. The lights and darks further amplify the volume, light on dark and dark on light.

The impact of the lighting and volume is intensified because so much of the image is fragmented. The idea is to avoid showing objects in their entirety so as not to give importance to things. Automobiles are included in places to offer con-trast with organic elements. But there is no formula for composition in these paintings; it comes out of the image.

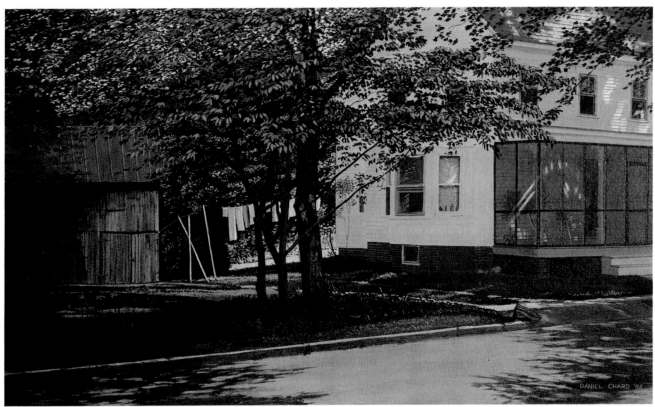

WOODSTOWN
1985, acrylic on paper, 8″ × 14″ (20 × 36 cm), private collection, courtesy of O.K. Harris Works of Art

The greatest contrast in this painting is reserved for the backyard. It is brought out by the illuminated grass and the clothesline.

SELECTING PHOTOGRAPHS

I use my 35mm camera to "sketch" scenes that I might want to paint. The camera is capable of gathering a great deal of detailed information quickly, spontaneously, and more accurately than I could by doing laborious drawings on the spot. Afterward, I study my photographs and decide how much potential they have as painting ideas.

The backyard photographs shown here were taken within a few days of one another. Most were of scenes I had passed many times before deciding to photograph them. As I photographed, I responded to what I saw in the scenes, not fully cognizant of how easily one or another would translate into a painting idea.

The photographs are arranged here according to painting potential, from most (Photo 1) to least (Photo 6). I don't expect a photograph to be much more than a starting point for a serious painting. I do, however, look for a photo that will take me as far as possible in suggesting spatial solutions as the painting develops.

PHOTO 1. It is interesting to compare my initial thoughts about this photograph with my painting of it. From the start, I like the contrast in the photograph, although I do not allow the painting to go so dark. In particular the highlights in the white building and the monolithic shadows provide strong value contrasts. Because of their size, these areas become the painting's standard for contrast, not only in value but also in scale.

The three-dimensional feeling is increased by the contrast of distant details with the larger shapes. For the sense of scale to carry, however, attention must also be given to nuances within the larger shapes. And the correct sense of scale depends on more than details; it is also a matter of not generalizing.

The foreground building on the right helps demarcate the volume from the immediate foreground to the central house to the deep space—although I feel the painting needs to show more of this building, including part of a window. The angular perspective then gives energy to the image, with the angle of the dominant shadow picked up in the central house and the cars.

I am particularly impressed with the opportunity this image gives me to suggest volume with dark on light and light on dark. The foliage is a variable to be played with in this regard. It needs to "obscure" the house to the extent of making it clear that the painting is not about the house, but rather about space and light.

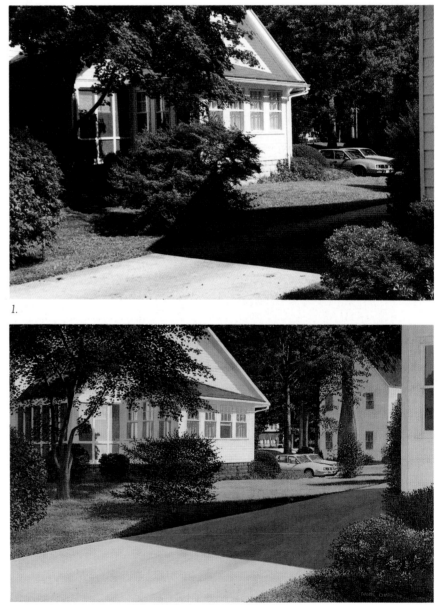

1.

HIGHLAND TERRACE
1986, acrylic on paper, 11″ × 16″ (28 × 41 cm), private collection, courtesy of O.K. Harris Works of Art

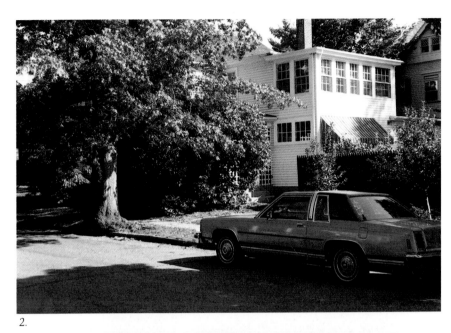

2.

3.

PHOTO 2. This image has most of the important ingredients of my general backyard idea. I like the angle of the house, curb, and car moving to the left while the strong lighted area moves diagonally to the right in front of the car. The lighted area could become the focal point as it moves into the white house. Perhaps there could be an opening through the foliage to show a front yard in light. And maybe more of the back porch (now hidden by the tree) could be shown.

The car in front could be too dominant as a mechanical form, but the fact that it is in shadow reduces its importance. The car becomes part of the contrasting dark frame across the bottom of the image. The highlight on the tree trunk provides a strong vertical and the curb, a strong horizontal.

Structurally, the back of the house and the car can be tied together. The car might need to bleed off the right side to reduce its importance. The blue in the car and awning could add some continuity through color. The background house in shadow might then be redone in various ways to make it more interesting—for example, by showing the reflection of the white house in the windows.

Overall, however, this image does not strike me as strongly as the first. It doesn't have the natural potential for a sense of scale, and major changes would be necessary. Altering the shape of the large foliage, opening up the front yard, and making the fence more interesting—or eliminating it entirely—could be explored as ways of making the image stronger.

PHOTO 3. This picture has foliage, a screened-in porch, modest architecture, and an opportunity to include a distant vista. It could work as a painting, but I prefer more complexity.

I think the biggest weakness in the image, as far as the backyard concept is concerned, is the lack of darks overall; darks cover just a limited area in the large white building on the right. If I were to paint this image, I would bring the tree shadows into the foreground and up the side of this building. The foliage in the large tree could be brought forward to justify the extended shadows. I would also like to see some foreground foliage moving into the image from the right, breaking up the white building and creating more shadows.

I would definitely bring the distant vista into a painting of this scene. The focal area would be between the large tree and the porch. By moving the car and the foliage, this area could be opened up, showing more of the distant vista and creating a rectangle for a painting within a painting.

Lastly, I would probably enlarge the screened porch and emphasize the transparency of the screens to get more play out of this area.

PHOTO 4. This rural scene has the contrast so basic to my backyard idea. The middle-ground cars, garages, and adjacent horizontal plane could be made very luminous to contrast with the large dark areas. There is also a contrast in scale. Moreover, the foliage at the top and the shadowed grass in the foreground could provide a natural frame for the rest of the image.

What this image lacks, however, is the structure given to the horizontal plane by sidewalks and roads. The large expanse of lawn could be shaped with shadows, but it would not be so easy to relate it to the architecture. Moreover, the volumes of the architecture are not so clear. The development of the architecture requires a better view—preferably one showing two sides of the building, with one side in shadow. If the base of the building were at an angle to the horizon, that would also provide a better sense of volume. A shadow running across the horizontal plane and up the side of the building could provide additional clarity and unity.

In the photograph, the only indications of three-dimensionality on the brick house are the shadow under the porch roof and the overlapping porch posts. The large tree trunk and bush in front suggest the volume between the foreground and the house, but they do not clarify the volume of the house. The darks inside the garage are the best indication of volume in that structure.

PHOTO 5. This image has a distant vista framed by darks; the danger is that this vista could become a focal point at the expense of the rest of the image. What it needs are more areas of interest such as reflections in the car and more development of the back porch, the side of the garage (now hidden behind the bush), and the shed. Cropping the photograph on the sides and bottom makes for a much more interesting image. Reducing the amount of lighted grass in the foreground alone brings the image much closer to an acceptable backyard scene.

Notice that the dominant shadow provides a structural support at right angles to the verticals in the architecture. It would help, however, to have a better angle of view, showing the house as a more convincing volume and revealing more of the garage, as well as the back porch.

PHOTO 6. This image has strong backlighting, indicated by the yellowish leaves. But it also has a number of weaknesses. The strong diagonal of light is not countered by a diagonal moving in the opposite direction. The building on the right has little intrinsic interest, and its volume is defined only by the receding roof line. The car and bushes have some appeal, but the left side of the image in shadow is quite unremarkable. Highlighting some trees and bushes and developing the horizontal plane could provide some interest. The building on the left should also be clarified.

4.

5.

6.

A STEP-BY-STEP DOCUMENTATION

It has become common for books on painting methods to present the step-by-step development of paintings. As I thought about showing how I develop a painting, I remembered what I had seen in other publications and wondered what I could do to make my presentation more valuable for the reader. My fundamental concern was to communicate something about the creative process—not just how one step follows another, but how conscious and unconscious decisions are made.

Of course, there is no one way for an artist to work; working methods and behavior vary, just as individual personalities do. In presenting a painting in process, I am not showing how a painting "should" be done, but providing an in-depth example of how one particular painter thinks and operates.

While putting together this step-by-step presentation, I was very conscious of changes in the image, stopping to photograph when these changes occurred. Documenting the painting process in such thorough detail inevitably affected my work, at the same time that it revealed important aspects of the painting's development. And I should point out that this is not the way I always paint. Many of my paintings are developed more spontaneously and directly, with fewer intermediate stages—for example, *Gardiner Farm* (pages 123–125).

For a painting to go in the right direction, one must bring to it a knowledge of the subject matter and a natural way of handling the paint, clear strategies for developing various kinds of imagery, a sense of the space within the picture frame, and the ability to integrate all these elements during the painting process. It is the integration process that is the most difficult to master—

there is so much to think about that many decisions must be automatic.

It is important to remember that the painting process is infinitely complex. It is not a matter of five, seven, or ten steps. The more a painter commits to this process, the more remains. That's the challenge and the attractiveness of the arts. I think it is less than fair to the student to oversimplify the complexities of the painting process.

This is not meant to be discouraging, however. I have faith that eventually one can integrate what one has learned, for the mind is a wonderful thing. I will never forget something I observed when I was twelve or thirteen. I saw an athletic boy go around a corner too fast on his bicycle. As he fell to the ground, he rolled up in a ball and rolled across the street. He didn't get a scratch. As a person with ordinary coordination, I was very impressed, and I never forgot the incident. In my early thirties, I was playing tennis and lost my balance running toward the ball. As a kid, I would have hit the hard court, palms and knees first. During the split-second before impact, I realized what I had to do, and I rolled—without a scratch. My first impression of the bicycle fall, and my rethinking it, had been a rehearsal for this fall, and I was prepared to act in a split-second.

We think of rehearsals as applying to the performing arts, but they are also important for painting. For an artist, every act of thinking, looking, drawing, and painting is a rehearsal for the next painting. To be good at something, one must study all about it—every component of the problem. If there is a particular part of the painting process that presents difficulty, the artist must work on it diligently. You never really know when the payoff will be.

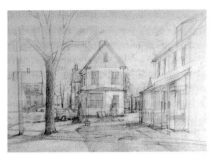

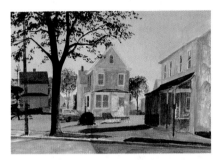

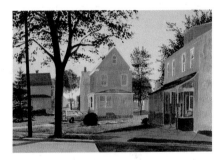

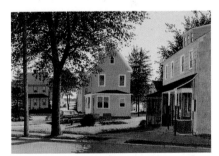

THE PAINTING PROCESS 131

INITIAL PHOTOS. This scene has pleasant associations for me: the building on the right used to house a bakery, which was the best in the area. But much will have to be done to make the image work as a painting. My photographs provide very little information on the middle ground; beyond the foreground, much will have to be fabricated.

The bakery building itself has some intrinsic interest. The glass window and the screen porch provide transparency and reflections, while the verticals of the windows and posts help to structure the image. The brick offers contrast with the greens, as does the color of the car. Moreover, the building contains a range of contrasts from dark to light, even though it is entirely in shadow.

The shadow the bakery casts could be manipulated to serve the needs of the painting; it could be used as a diagonal reinforcing the angle of the building, countered by the direction of the light and the car. I am not sure about the tree in the center, however. It is not an ideal focal point for a painting; given its central location, it should contribute more to the composition than it does. I think this tree could be thinned out to show more of the house, giving more structure to the center.

Ultimately I think I will need to add not only much more of the central building but also some structure on the left to offset the bakery's dominance. The large tree on the left, with its foliage, does counter the bakery to some degree. The appeal of this area is also aided by the car.

The foreground can serve as a dark framework, providing structure and contrast (dark against light) for the painting. To make the composition stronger, however, it seems best to alter the panoramic format of the photographs to a more rectangular shape. Also, the angle of the bakery seems too strong, making the bakery too dominant.

I have no immediate ideas about the shape of the foliage and how it will interact with the structures. The method that I often use to develop foliage, one leaf at a time, requires the sky to be laid in first; then the foliage evolves in response to the rest of the painting. I try to anticipate where it will go, but I also have to see how it develops.

STEP 1. *After giving a piece of hardboard two coats of gesso with a short-haired paint roller, I draw in pencil on the surface. Although I have decided on the basic format, I am still undecided about the top border. As the verticals and horizontals of the composition become more established, it will become clearer where the top needs to be.*

Essentially I begin by blocking in the main shapes, considering their relationship to the frame. My decisions are based on my feeling for the space. A line or shape goes in because it needs to be there. The structure then evolves from the lines in the buildings, the pole, and the dominant tree.

The volume of the image seems to be developing into a rectilinear "container," defined by the front of the bakery and the back of the central house, with openings between the buildings showing deeper space beyond. The simplicity of this volume can be a strength.

At this point I am mostly concerned with perspective and composition, and my development of the image is primarily linear. I have some ideas about the lights and darks, particularly in creating the backlighting, but the specifics are not yet clear.

My first major change from the photographed image is in the angle of the bakery.

Had I left the racing perspective of the original, there would be no corresponding energy on the left side. Further, since the eye tends to move from left to right when viewing a painting, the visual movement to the right needs to be slowed, not accelerated, by the bakery.

As each space is suggested—from the left edge to the pole, to the tree, to the middle house, to the bakery—the size of the bakery becomes clearer to me. It isn't only the bakery's perspective that changes, but also its proportions. I want the bakery to project itself into the middle house, interrupted by the opening into the distance. Although I'm not sure what I want to do with the opening yet, I like the spatial tension between the end of the bakery porch and the right side of the middle house. Both buildings are securely placed on the horizontal plane; their bottom corners relate to one another; and the shape of the interval between them is firm.

A similar relationship can be developed between the left side of the middle house and the large tree. Also, there is a strong shape between the tree and the pole. The space from the pole to the edge, however, doesn't take on any special importance—which is as it should be.

In laying in the center house, I include the roof line, even though I intend to obscure this

later with foliage to reduce its energy. To carry the space back and simplify the volume, I suggest a second house behind this one. I am not sure what kind of building I'll put on the left, but it should reinforce other major divisions in the painting and frame the second opening into the distance.

Developing all these houses requires some knowledge of this turn-of-the-century architecture. Having lived in such a house and studied it closely gives me some ideas. I am aware, however, that if I don't refer to photos and instead try to make up these structures, they may become too similar.

Although I don't work on the shadows yet, I know they will be moving across the front from a light source behind the bakery. The car is the only object parallel with the direction of the light. It will be generally in line with the shadows of the bakery, tree, and pole.

Notice that in my composition the two openings into deep space divide the picture plane into approximate thirds vertically. Having details of strong interest in these areas will strengthen the painting. Including these areas of deep space expands the range of possibilities in the image, from deep to shallow and from small to large, producing a better sense of proportion and scale.

STEP 2. After changing the bakery's angle in my drawing, I go back to photograph the bakery from this angle. I also photograph the other buildings (although these photographs are not shown here). I feel the center buildings should be seen from an angle, showing more of their sides. Not only will this amplify their volumes, but it will give more energy to the painting; in my original photos, they seem static.

With my additional photographs, I begin to refine the drawing and, in particular, the proportions of the bakery. In modifying any spaces, however, I consider the existing dynamics of the image. If possible, I would like to remain within the general confines of the existing shapes—although this is not to say that changes can't and won't be made.

Notice that the repetition of shapes in the dormer windows of the bakery, the corner of the roof, and the porch roof creates a two-dimensional movement. These angles correspond with similar ones in the middle house. The initial photos showed only part of this house's roof, but if I run it all the way across, it will relate to the bakery roof. Photographs showing the middle house from different angles give me ideas for representing the back of the house and the roof.

I also need to decide on the windows for this house. I can't "fudge" very much because the way I paint is to use a brushstroke for each board, with a definite idea of where I am going. The windows in the actual house are distributed symmetrically, but that could be deadly for the painting. Varying the windows, foreshortening the side of the house, and including some shrubbery should add interest to this area. The foreshortened house in the distance will also make the center area more dynamic, as it continues the direction of the planes in the central house. Further, it should help to break up the symmetry of the central house. The overlapping foliage from the large tree will then be my "ace in the hole," because I can manipulate it to reveal or conceal the houses as I want.

The house on the far left, suggested only slightly in my initial drawing, is now developed with attention to the way the right side relates to the left side of the tree. Its middle-ground location will be clearly understood from its size, the overlapping of the pole, and some kind of foliage; but this house needs to contribute to the dynamics of the two-dimensional picture plane as well. I do not develop the left side of this house in much detail because it could too easily attract attention toward the left edge of the picture.

The car is going to attract attention. It is part of a series of overlapping planes, and it opposes a variety of verticals near it. The car also participates in a strong horizontal movement developing across the image. Structurally, this movement will function as a horizon. The line is not uninterrupted, but this only makes it more interesting. As part of that horizontal, the car has some horizontal lines, but it is in fact set at an angle to the picture plane. This adds a great deal of energy to this area. Moreover, the

car frames the interval above it. The tree behind the car then adds to the energy in this interval and provides some contrast for the deep space.

Although the foliage is still not developed, I know that with additional trees I can establish darks to contrast with the bright areas of the scene. Indeed, trees and shrubs can be added at any time to give more shape to the painting. Intervals suggesting distance can be made more convincing by buildings, shrubs, and trees.

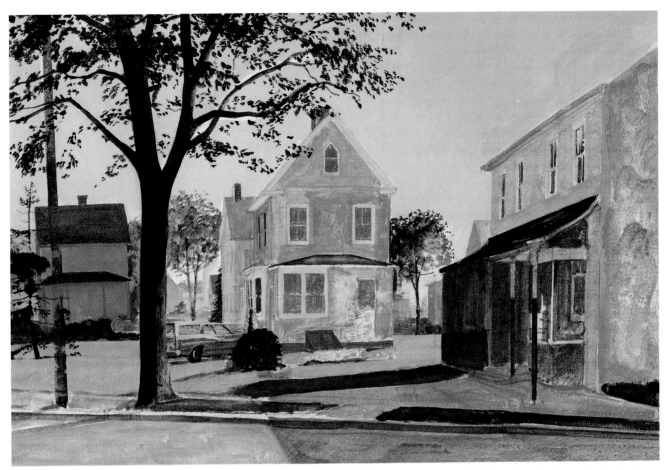

STEP 3. Taking up my paints, I lay the sky in first, gradating it slightly. Next I put in some of the darks, to get a better idea of the painting's overall look. Initially I make the darks in the bakery quite strong—stronger than they will be once the porch becomes transparent. I lay in the darks of the tree flatly, without much indication of volume at this point.

The shapes of the trunk and branches show some consideration for the composition. The trunk is vertical but has a slight bend near the bottom. The main trunk moves slightly toward the left at the top, while the variety in the branches is to the right. You could say that this tree faces right, with its back to the left edge. There is a long way to go in developing it, but I can already see how its dark vertical will tie in with the bakery's cast shadow, as well as the darks in the bakery itself.

With the foliage, there are some practical considerations in laying in the darks: because acrylic is a transparent medium, it is difficult to see a light green on top of a light blue sky. Only later will I be able to define the leaves by placing light greens on top of the initial darks.

After blocking in the house on the left, I decide to use an evergreen tree to soften its left side. Even though this house is parallel to the picture plane, it is not a major shape in the painting; its contribution will be its role in establishing the structural horizon.

With the central houses, the base of the more distant house cannot be seen, so the distance between the two houses has to be indicated by relationships between the windows and the roofs, and by how much of the back roof is seen. I intend the houses to be in shadow, with only a limited range of values. Also, by keeping their colors flat and cool, I will be able to give the grass a warm luminosity.

The blue-grays, blue-greens, and washed-out greens of the houses begin to create an overall unity with the sky and the foliage. Against these greens and blues, browns provide occasional contrast. The bakery's gray-brown and brick colors set the tone for other browns in the painting. A brownish color gives even more importance to the car, which already varies so much from other elements—as a horizontal against verticals, a mechanical object against organic forms, and a reflective surface against nonreflective ones.

To diminish the importance of the car as "car," I lay in a large, round bush. The bush provides an interesting abstract shape in this critical area; it is not quite what I want, but it may lead to something.

One area that gives me a lot of trouble is the bakery roof, with its strong shape against the sky. I consider putting foliage behind the building, but keep in mind that a sizable tree would block the light. At this point I experiment with dropping out the dormer, but it doesn't work, and I later reinstate the dormer. The long, straight line tends to draw the eye away from the focal point, toward the upper right corner, with no reward.

The intervals between the buildings seem fairly strong, almost like vertical columns. Maybe the trees within each space are too much the same—one here, one there—but that can change later. A suggestion of deep, luminous space helps me see the possibilities.

In terms of the paint itself, I begin to establish a solid base for developing representational surfaces. Since acrylic is transparent, it needs to be layered to suggest substance. Here I apply a second layer to the blue house. In general, as I apply the new layer of paint, I follow the direction of the plane, overlapping any foreground shapes, as can be seen here with the foreground pole. While the blue-gray paint is wet, I gradate it slightly to suggest shadows under the roofs. Then I begin the evergreen on top of the house.

I also layer the grass with two greens, the second a little yellower than the first. I blot the moist paint with my fingers to imply some texture and keep the surface from becoming flat. The repeated layering of paint on the surface has, I think, a great deal to do with creating a successful illusion of three-dimensional space in the finished painting.

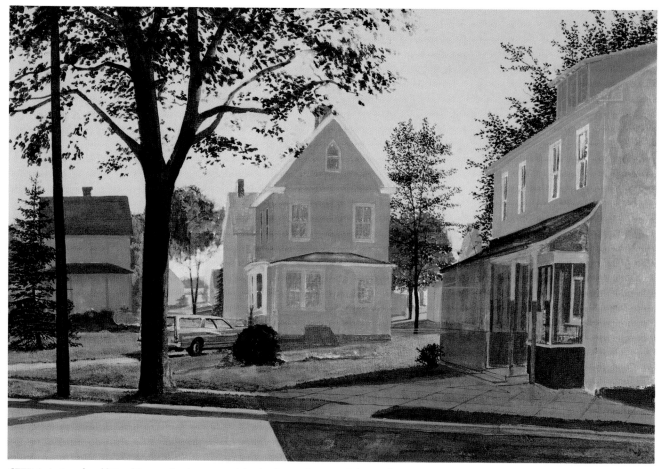

STEP 4. As I apply additional layers of paint to the buildings, I try to establish a solid surface, even if this obscures the windows (they can be re-established afterward). Then I develop the store window of the bakery with further washes, devoting more time to this reflection than the other surfaces. At this point, as I define the window, I am still trying to understand it—what I want to do with it.

Behind the bakery, I lay in some foliage, keeping the shape diverse and diverting the eye from the perspective of the roof. I also reintroduce the dormer from my drawing,

giving it a layer of paint and then outlining its windows. The white lines on the gray indicate actual boards in its structure.

Turning to the grass, I dab a dark green over the illuminated area to imply texture and use a darker range of green-grays wherever the grass is in shadow. By working the grass within a limited value range, I can imply texture without using much contrast; eventually, as I add more layers of paint, these textures will become more luminous as well as descriptive. The top edge of the shadow in front of the bakery begins to show the texture of the grass,

since the grass in shadow is actually silhouetted against the lighter background grass. The bush, added at the corner of the bakery, then reduces the severity of the angle between the shadow and the porch.

In the foreground, the cast shadows become more definite, defining the horizontal plane. The grid of the sidewalk provides some direction, although I will reconsider this pattern later. The shadows of the large tree and telephone pole across the road begin to suggest believable space, but there is still a long way to go.

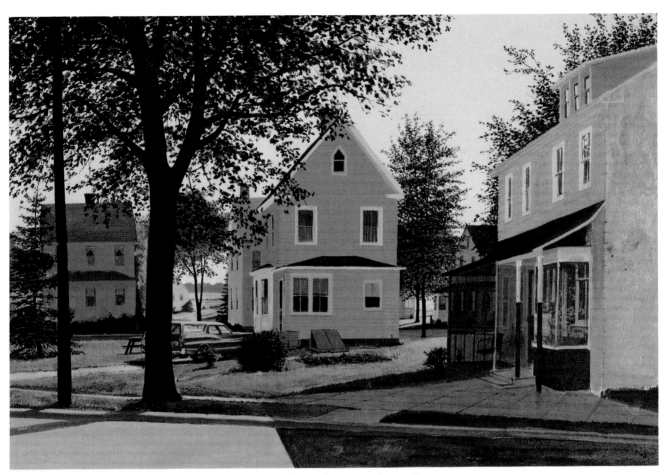

STEP 5. At this stage the windows are clearly established in all the buildings. I give attention to the actual construction of the windows and suggest curtains inside them as well as the darks. After lightening the curtain color just a little, I apply thin washes to model the curtains. I construct the window frame again with grays, holding back on whites and off-whites until the end. The second-floor windows of the bakery building can be read as dark vertical bands. Note that the bottom window is slightly inset.

Next I give shape and color to the house behind the bakery, which can be seen through the screen porch. I also add objects to the porch to help describe its volume. I give the storefront window area a little more definition, primarily in the reflections, and allow the background to show through the screen porch, graying the colors to suggest the screen. The contrasting green-and-white posts help to clarify the volume under the porch roof.

As the deep space is clarified, I have an idea for a porch on the left of the opening. I add shrubs and continue to clarify existing detail, working dark on light and light on dark. The tree foliage at the top of the opening is developed more fully. It will probably become a continuous organic pattern across the top.

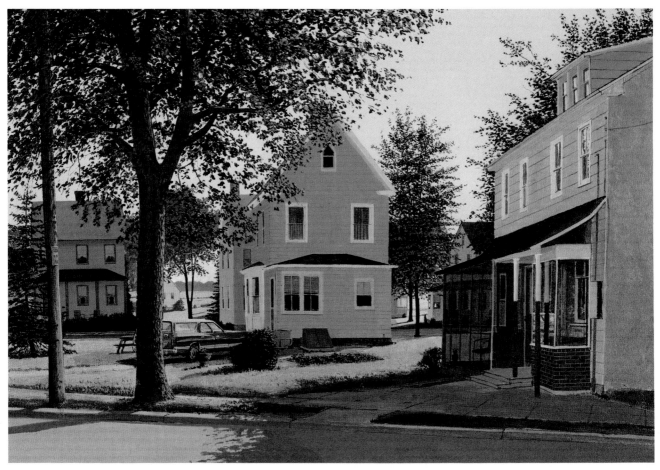

STEP 6. As layer after layer is added, the image becomes clearer and clearer. Details are refined. The stucco pattern on the side of the bakery, for example, emerges as I play with the paint. The gray paint on the bricks under the foreground window suggests the mortar.

On the left, I add a front porch and chairs to the blue house. To make the large tree and telephone pole in front more convincing, I bring out the volume with highlights and suggest appropriate textures with vertical smears and brushwork. Working light greens into the foliage of the large tree also increases the volume. The challenge is to keep the organization of the foliage from becoming too regular, so it feels "alive."

Accounting for the shadow of the tree behind the bakery, I soften the edge of the foreground shadow, so it is no longer so harsh. As this shadow becomes more ambiguous, there's less of a tendency to focus on its edge. Instead, attention is directed into the contrast and clarity of the middle ground and the intervals, with their views of deep space.

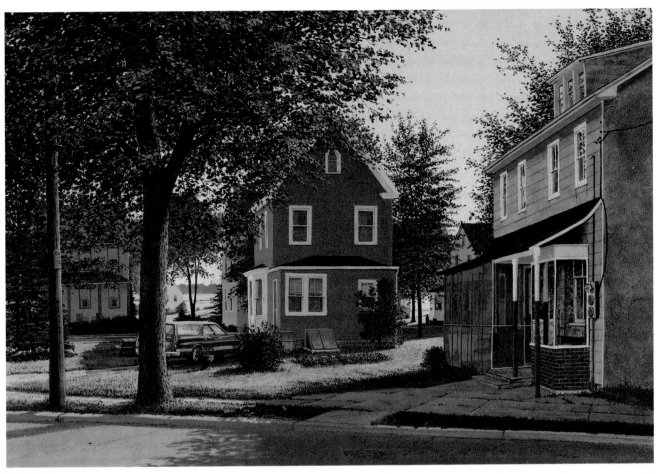

BAKERY
1986, acrylic on paper, 11″ × 17″ (28 × 43 cm),
private collection, courtesy of O.K. Harris Works of Art

STEP 7. In this final stage I am mostly concerned with making the image work as a painting, pulling it together. Stopping, step by step, to photograph the painting and describe what I have done alters my normal process and does not promote unity in the image.

The many openings in the foliage of the large tree in the previous stage seem distracting, so I add a lot more foliage, bringing attention down to the car area. I also put in a large shadow behind the car. Although this shadow was planned earlier, I wasn't sure how to do it. The challenge is to keep the shadow from going too flat; I think the picnic bench makes it more convincing. Both the shadow and the dark foliage, added just above the car, give more contrast to the lights in that area.

Darkening the center house and adding a small tree at its right corner reduce its impact as a shape. The darker building then provides more contrast for the illuminated areas. Also notice the foliage between this building and the one behind, and how it suggests the interval between them.

To indicate the screen frames on the back side of the bakery porch, I add a few more verticals. The verticals in front then receive slight highlights to bring them forward. Light grays dabbed on the screen simulate the play of light on the texture of the screen.

After adding lights to convey the volume of the tree behind the bakery, I re-establish the edge of the roof. I also work on the trim—dark lines had been added in the previous step, now I use off-whites to bring the trim back. Often single brushstrokes represent single pieces of trim. Turning to the windows, I apply off-whites to enhance their shape and the illusion.

Other final touches include the softening of the windows of the blue house (which had attracted too much attention) and the addition of grass in the cracks of the sidewalk.

Throughout this book I have tried to present strategies for overcoming some of the major obstacles in developing realist paintings. To show, at the very least, what is technically possible with this approach to acrylic painting, I have included some of my students' work here. I have also included a "checklist" of solutions to some of the main pitfalls encountered by my students:

1. Have more information than is needed. Use a telephoto lens to get extra information, particularly about complex patterns. These photographs will help the translation process. All realist painting departs from the way things "really look" at some point in the translation of information from the subject to the painting surface. Whenever a painter departs from the primary information, however, and begins to make things up, there is room for error. Few painters have such an accurate visual memory that they can develop images without references. If there is an overabundance of information, it is more likely that the translation will be effective, without dependence on assumptions or conventional interpretations.

2. Work with a manageable format. There are decided advantages to working small. Control of the image is paramount. Working too large can compromise consistency in technique and continuity in the image. Remember: scale is the result of proportion, not size.

3. Keep the image the same size as the reference photographs and drawings until control is achieved. Working one-to-one in this way simply eliminates an unnecessary variable.

4. Analyze the volumes and planes. Think spatially first. Reduce the image to its simplest shapes.

5. Study the subject in the real world, going beyond its appearance to observe its functions, insides, and more. A painter can't know enough about his or her subject. One never knows when this information will be useful in the development of an image.

6. Develop the image as a total image, working from the whole to the parts.

Susan Bowe, **UNTITLED**
1986, acrylic on paper,
7″ × 11″ (18 × 28 cm)

This is Susan Bowe's first painting, although she already knew how to draw and had completed the photo-extension exercise (see page 119).

Diane Zaugra, **TILTON ROAD**
1985, acrylic on paper, 5½″ × 14″
(14 × 36 cm), courtesy of
Rosenfeld Gallery, Philadelphia

Diane Zaugra is a professional painter, represented by Rosenfeld Gallery in Philadelphia. She is extremely skilled in the use of acrylics and has a good sense of composition. In developing this painting, she limited her palette to the primary colors plus black and white.

Michael Schweigart
ROUTE 611
1985, acrylic on paper,
14″ × 20″ (36 × 51 cm),
private collection,
courtesy of Rosenfeld
Gallery, Philadelphia

*What is remarkable to me
is that this is only Michael
Schweigart's third painting.
For him, painting is truly a
natural process. Here he
"played" with the subject
matter.*

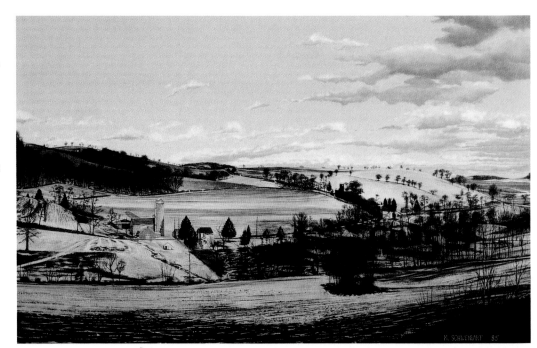

Sally Funk, **CHANGE OF SEASONS**
1985, acrylic on paper,
8″ × 21″ (20 × 53 cm)

*As a veteran watercolorist, Sally Funk adapted easily to the acrylic techniques discussed in this book.
Among her strengths is her ability to develop surface patterns with acrylics.*

Robert Rex
UNTITLED (Detail)
1985, acrylic on paper,
4″ × 6″ (10 × 15 cm)

*Robert Rex uses acrylic
almost like watercolor in
developing his painting.
The image is relatively
bright because of the influ-
ence of the white paper on
most of the color. This
approach, however, re-
quires extreme skill, as
there is little "play" with
the paint.*

James Mack, **UNTITLED**
1985, acrylic on board,
5″ × 10″ (13 × 25 cm)

*James Mack's small painting shows the use of a ruling pen on finely sanded gesso. The weight of the
lines drawn with the ruling pen gives an almost physical weight to the architecture.*

INDEX

Edited by Sue Heinemann
Designed by Areta Buk
Graphic production by Stanley Redfern
Text set in 11-point Berkeley Oldstyle Book